Michael Foreman
A LIFE IN PICTURES

PAVILION

To Louise,
my light
my rock
my love.

First published in the United Kingdom in 2015 by
Pavilion
1 Gower Street
London
WC1E 6HD
An imprint of the Pavilion Books Group Ltd

Illustrations and text © Michael Foreman, 2015
Volume © Pavilion Books, 2015

A CIP catalogue record for this book is available from
the British Library.

ISBN 978-1-84365-299-1

10 9 8 7 6 5 4 3 2 1

Printed and bound by Toppan Leefung Printers Ltd,
China

This book can be ordered direct from the publishers
at the website www.pavilionbooks.com, or try your
local bookshop.

OPPOSITE PAGE: *I still have a photograph of
me as a bald baby. I was born just one month after
my father's death. A husband replaced by a baby.
Not much of a deal. Not when my mother already
had two sons.*

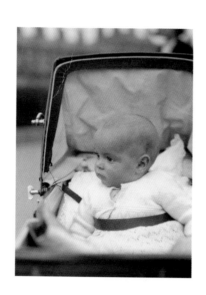

Contents

Foreword

Goodness only knows how many books this man has created in words, pictures, or both. Goodness only knows how many awards he has won, into how many languages his books have been translated, how many plays and films have been adapted from his books, or how many great and good causes he has supported with his work. His life's work is mountainous in scale and scope, certainly, but not I think to be measured in bare statistics. It is rather to be judged and calculated on the effect his books have had on countless thousands, millions indeed, of young people, all over the world, whose lives have been touched and immeasurably enriched by his stories and his pictures. Yet so many of these children will be unaware of who he is or what he has done. For here is a man inclined to keep away from the limelight, who goes about his art and his craft quietly, modestly – who is not, and has never been in any way, 'puffed up'. So how appropriate it is that there is now to be a retrospective gathering of his work. Well, about time too!

Part of the problem with assessing Michael is that his works have been so various over the years. He has never slotted himself into one convenient repetitive niche, has never courted narrow popularity. Of course he has illustrated numerous picture books – that's how he began, with *The General*, decades ago now. Then there were folktales from all over the world, legends, poetry, short stories, novellas, novels. He has designed posters, and worked on books and magazines for grown-up children too.

But what sets him apart from so many of his fellow great illustrators is that he is as powerful when telling stories in words, writing them down, as he is when he draws and paints them. This man – irritatingly for someone like me who is only capable of using words to tell his tales – can do both words and pictures equally brilliantly. Whether in his writing or his illustrating, Michael Foreman has found his own unpretentious voice. He tells it, draws and paints it, as he hears it, as he sees it in his mind's eye. He is the complete storymaker, words and drawings in harmony, a seamless fusion, born out of supreme skill and of a natural spontaneity that is the hallmark of a truly great storyteller; and he is as comfortable telling stories of the First World War, at the Western Front or Gallipoli, as he is with his seaside tales of soggy teddy bears and sand horses.

I have over the years made about 25 books with Michael, 'the other one' as I call him, and he calls me. He has worked with many writers over the years, Terry Jones and Angela Carter among them. But when I think of our relationship, I know that our collaboration has gone far beyond that of a normal author/illustrator association. From the very first it was, more often than not, Michael who suggested which stories we might work on together. He it was who suggested, and indeed arranged, that I should retell the story of King Arthur, for him to illustrate. We loved doing it, and made a great book together. He then suggested *Robin Hood*, then *Joan of Arc*, then *Beowulf*, then *Sir Gawain and the Green Knight*, and with every one we did it became obvious that this was a genuinely close collaboration. We were in effect one storymaker, our voices as writer and illustrator inter-weaving, becoming ever more easy and natural with each book.

So much so that it wasn't long before Michael – the other one – was suggesting new stories to me, not retellings now but ideas he thought I might develop into stories that he might draw and paint. *Farm Boy* was his idea, the sequel to *War Horse*, *Rainbow Bear*, *Billy the Kid*, *A Medal for Leroy*, and a dozen or more others – all his ideas, originally. These became our stories, made by Michaels, told by them, each story born out of his generosity, a willingness to share fully in the creative process of storymaking. And out of this storymaking grew a great and lasting friendship.

But whether a story is originated by him or by me, Michael does not embellish or embroider it in his pictures. He complements any story, grows it, enriches it by his pictures, brings it alive on the page. And in so doing he complements me, and so many other authors he has worked with. So it is a joy, a sheer joy, and a great honour too, to be asked to write this foreword to Michael's retrospective, to be able to say: 'Once upon a time' there was this young Suffolk lad who found he could draw as well as he could speak, who's head was full of ideas, who loved to tell tales and discovered he could do it in pictures and words, his way, and that he loved doing it, loved passing on his stories to young and old alike, and became the greatest illustrator-storyteller of his time.

The Other One, Devon, spring 2015

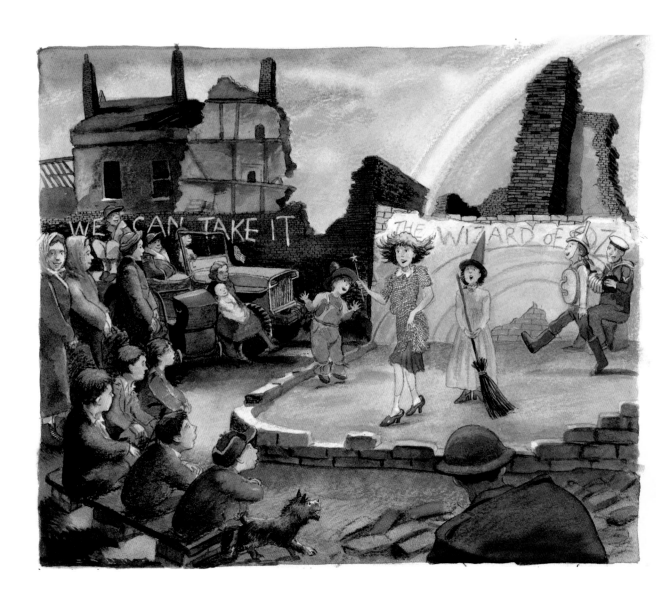

Over the Rainbow

Birds fly over the rainbow
why then oh why can't I?

Some time at the end of the War, the girls came out of the cinema singing 'Over the Rainbow' from *The Wizard of Oz*. We boys thought it would be a soppy film and didn't go. But the song stuck in my imagination. It spoke of somewhere else, somewhere, some day, you might get to see. Somewhere away from bomb sites.

As the beach was gradually cleared of mines and barbed wire, we could at last dip our toes in the cold North Sea. But dipping toes only whetted my appetite. 'Overseas' was no longer a place where men went to fight. It was now a big wide world to explore.

As the title suggests, this is a book of a life told through pictures – pictures and stories.

So – to begin at the beginning. . .

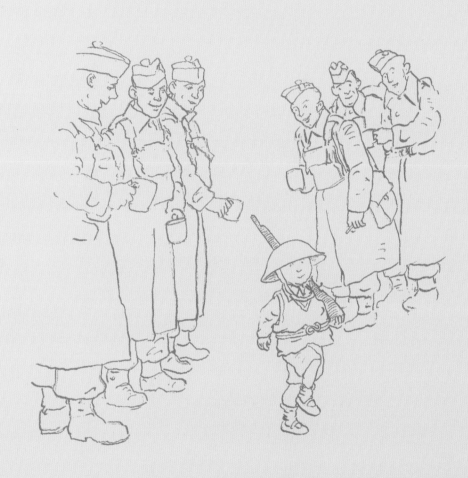

PART I

MEMORIES

War Boy

I wrote *War Boy* because my young sons were asking 'What was it like, dad, when you were a little boy?' I had to think back many years, beyond many adventures, through the jumble of childhood memories, to the first one. The very first memory.

It was ten o'clock at night, 1941. I was asleep when a bomb came through the roof, directly above my bed. It came through at an angle, missed my bed by inches, bounced around the room and ended up in the fireplace where it burst into flames. The flames went up the chimney. It was an incendiary, a firebomb, and of all the places in our home for a firebomb to land – it landed in the fireplace!

My older brothers ran into the room and put the flames out with a bucket of sand and a hearth rug. My mother grabbed me from the bed and we all made a dash across the street to our Anderson Shelter behind the fish and chip shop. The night sky was full of enemy bombers, their underbellies lit up by the blazing thatched roof of the village church. The anti-aircraft gun on the corner of our street was blasting away and the whole sky was bouncing as my mum's shoulder thumped me under the chin as she ran. That's how I know it's my own memory. No one else saw the sky bouncing – no one else was being bumped up and down by my mum!

Once I had written down that first memory, it was like taking a cork from a bottle. The first memory was the first bubble rising to the surface. Writing it down burst the bubble, allowing another to rise to the top. Then another and another. Each memory bubbling up and releasing another, until I had a full book – *War Boy*.

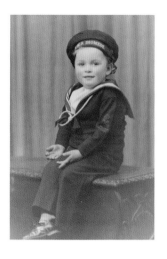

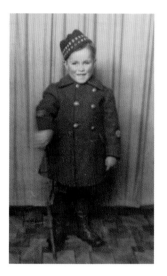

TOP: *Mum's friend, 'Pop the sailor' bought me my own sailor's uniform.*
ABOVE: *The King's Own Scottish Borderers, who came into our shop every day, had a special little uniform made for me.*

When working with children, I encourage them to do the same. To write down their earliest memories. To ask their parents and grandparents about their memories. Build up a collection of family stories and illustrate them with drawings and photographs. Many of the children come from other cultures and backgrounds. What a rich store of stories they have to share!

'I woke up when the bomb came through the roof. It came through at an angle, overflew my bed by inches, bounced up over my mother's bed, hit the mirror, dropped into the grate and exploded up the chimney. It was an incendiary. A firebomb . . . We spent a noisy night huddled in the shelter and returned home at dawn to find an unexploded bomb in our outdoor loo.'

ABOVE AND FOLLOWING PAGES: *Illustrations from* War Boy.

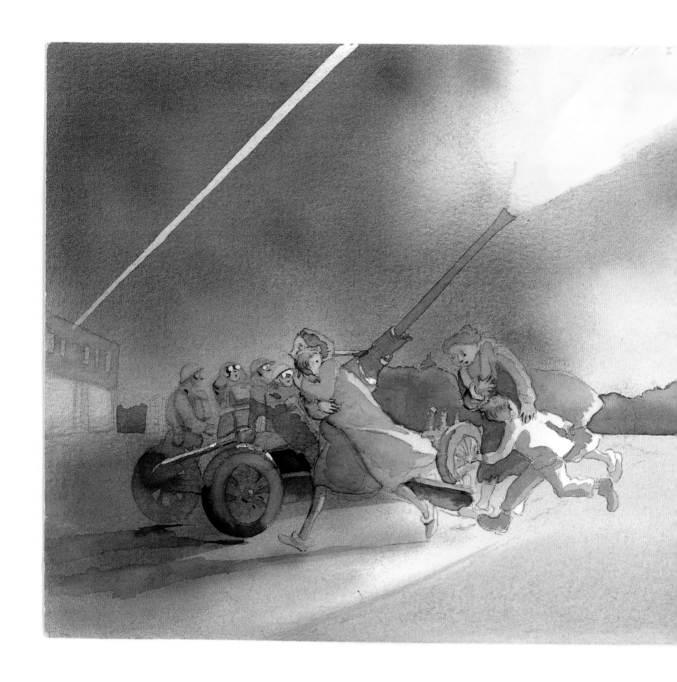

'Mother grabbed me from my bed. The night sky was filled with lights. Searchlights and anti-aircraft fire, stars and a bombers' moon. The sky bounced as my mother ran. Just as we reached our dug-out across the street, the sky flared red as the church exploded.'

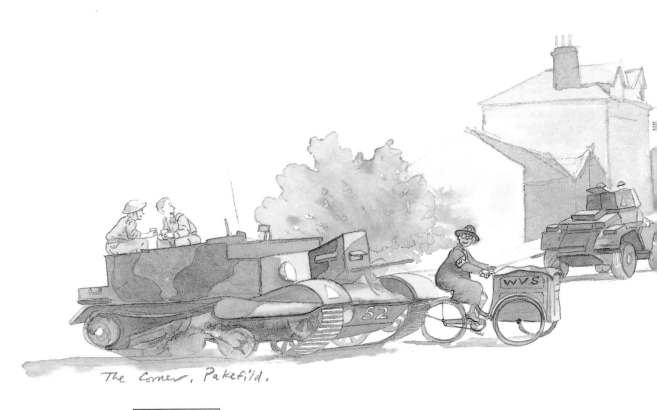

The Corner, Pakefild.

THE SHOP

My father died a month before I was born. To look after me, mum had to have me with her in the shop all day. She opened the shop at 7.30am every morning and closed at 7.30pm each evening except Sunday, when she closed at 1pm.

Before I could walk, I crawled around the shop. My world was full of legs. Soldiers' legs, sailors' legs, busmen's legs and, worst of all, little old ladies' legs. My day would suddenly go dark as I crawled accidentally under the long, black skirts of an old lady smelling of stale lavender and cat's pee. Growing up in the shop was fantastic. American GIs, Poles, Czechs, Australians, troops from all over the world came to our shop for cigarettes and cups of tea and inspired my desire to travel the world.

Late in 1942 the traffic past our shop began to include trucks and jeeps of the USAAF. We used to run behind the trucks full of waving men and shout 'Got any gum chum?' We were usually showered with

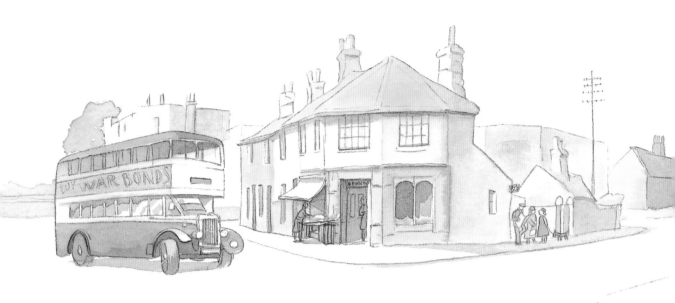

packets of chewing gum and biscuits. They spoke like heroes. They all sounded like cowboys. I dreamed that if I ran behind enough trucks they would spot me as the new child actor, like Mickey Rooney, and we would all go to Hollywood.

Very few families had bathrooms – just a tin bath hanging on a hook in the backyard. Our loo was in the backyard and there was a bus stop next to the wall of the loo. The Number 4 bus arrived at that stop every thirty minutes, but the queue of people started forming long before the bus was due. I hated going to the loo with a queue of locals chatting just the other side of the wall, especially if I thought I was going to be noisy (during the pea season for instance). I used to try to time it so that I was doing my business just as the engine of the bus was thundering away and so they wouldn't hear my explosions.

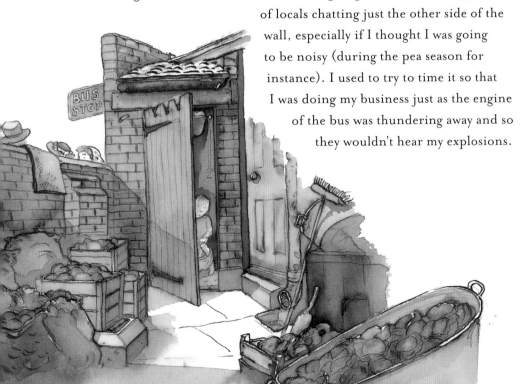

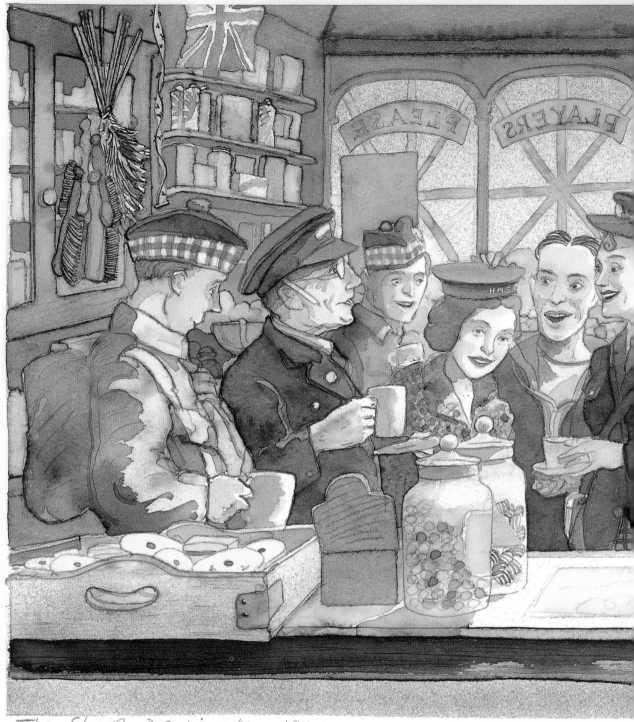

The Shop, Drinking tea 1941

'The soldiers and sailors stood about the shop and joked and told stories while they drank their tea, saucer in one hand, cup in the other and a ciggy smouldering between two fingers. Often they filled the shop and spilled out on to the pavement.'

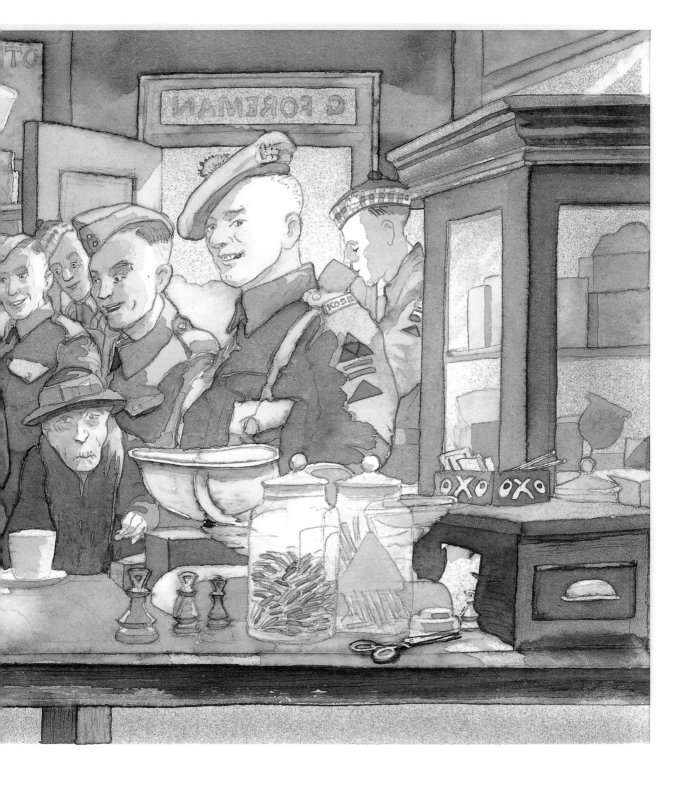

'One day, the scream of a falling bomb sent everyone in the shop diving into a heap on the floor. Tea everywhere. The house of Mr Lang, the chemist just up the road, was destroyed.'

'We were all sorry to leave Pakefield and it's people, it was home from home.'

Gus Dalgliesh KOSB

Our home behind the shop was 'open house' to the soldiers and sailors stationed around our village. We had no books at home and the stories which filled my young head were told to me by some of these men who, far away from their own children, perhaps gained some comfort from sharing stories with a little boy drifting off to sleep.

At Christmas, my mother would invite soldiers and sailors to join us in our family celebrations. Many of these men left for 'overseas' shortly after and, for some sadly, this would be their last Christmas.

For those young men, our shop, front room and kitchen became the nearest they had to a home from home, and many continued to send mum cards and letters after the war was over. One soldier in particular, Gus Dalgliesh, stayed in touch with me for many years and visited me and my family in Cornwall long after my mother's death.

Memories of mum's shop continue to pop up in my work. It features in the Dickensian street of *A Christmas Carol* and as Mr Badger's shop in Terry Jones' *Animal Tales* – Bull's Eyes on the counter, the old copper scales, windows full of fruit and the wobbly steps – all memories of a lucky, lucky childhood.

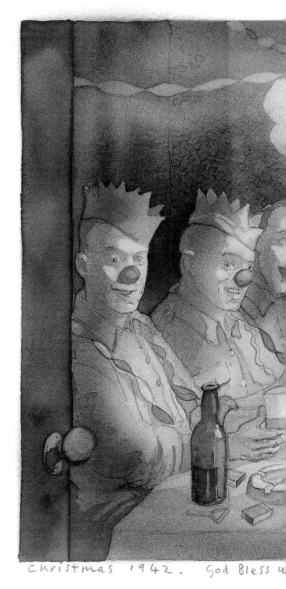

Christmas 1942. God Bless u

'Christmas night, 1942: I remember looking back into the room as Mother carried me to the stairs. A sea of faces in the smoke. They were dressed as soldiers and sailors but wearing paper hats. Other boys' fathers, sitting round our table wishing it was their little boy they had kissed goodnight.'

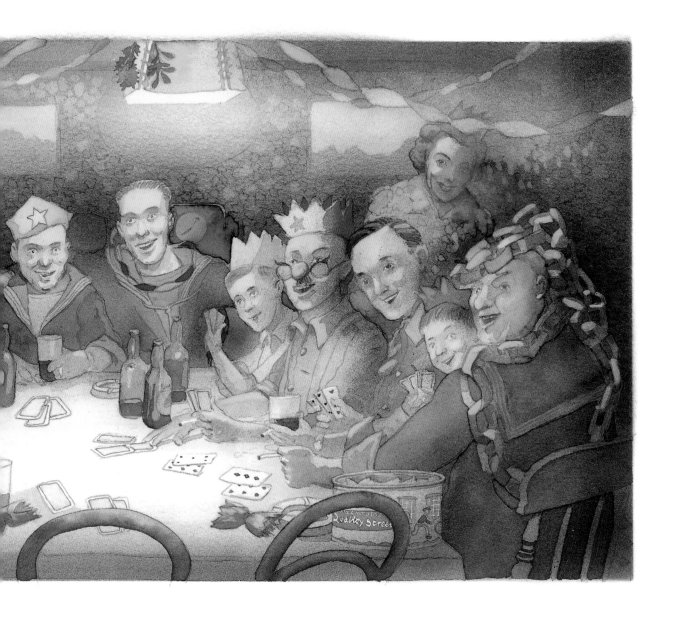

'Received your letter with the very sad news of your mother's passing, and with sadness in my heart her passing has left me with a little emptiness. But I am honoured to have shared in her friendliness among so many, for so many years. She was held in high esteem by her boys who frequented the wee shop on the corner, for their sweets, cigs, a coffee and a wee motherly chat – and when we have our reunion this year we will remember her.'

Gus Dalgliesh KOSB, May 1982

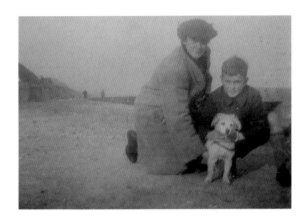

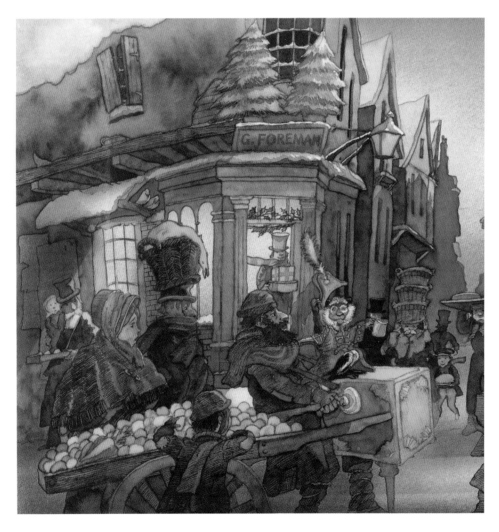

TOP: *Me, mum and Sandy; My mum's shop.*

ABOVE: *Christmas street scene taken from* A Christmas Carol *by Charles Dickens in* Michael Foreman's Christmas Treasury *and* Classic Christmas Tales.

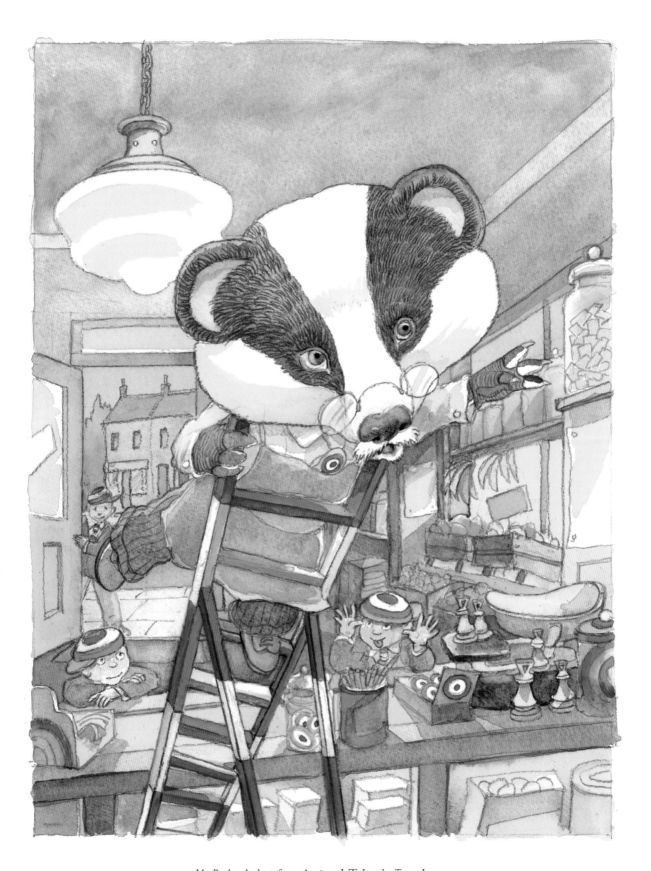

Mr Badger's shop from Animal Tales *by Terry Jones.*

TRAMPS AND FISHERMEN – A SOURCE OF STORIES

All children love stories, especially listening to stories. With no books at home, we relied on this special experience – a shared story. From time to time we had the treat of a real tramp on our patch. They usually set up a little camp on the 'bumps' beside the wood. We waited until invited to the fireside.

The tramp would tell us a few tall stories of the world. None of us children had been much further than the next village. Even the soldiers, the airmen and most of the young sailors, recently called up, had experience only of their home town or village. But a tramp, a 'King of the Road', could have been everywhere, and frequently told us he had. After bringing him bits of food from home, we watched and learned how to set up a fire safely, cook a pot of stew and spit with unerring accuracy onto the bobbing lid of the black boiling kettle.

It was only later that I realized some of these wanderers had found it impossible to settle back into 'normal' life following the trauma they had suffered during the First World War.

Another teller of tall tales was an old fisherman we called Father Christmas because of his long white whiskers. He told tales of his cabin boy days on the great clippers and sailing ships. On his first voyage he got homesick and jumped ship in Falmouth, the last stop before Rio. He hitched and worked his way through Cornwall and all the way home to Lowestoft. This was the first I had heard of Cornwall. He described it as a land of rocks and shipwrecks.

Later 'Pop' the sailor would tell me more. But I was already hooked. Now, every time I drive over desolate Bodmin Moor towards my studio at St Ives, I think of the cabin boy hitching home to Suffolk.

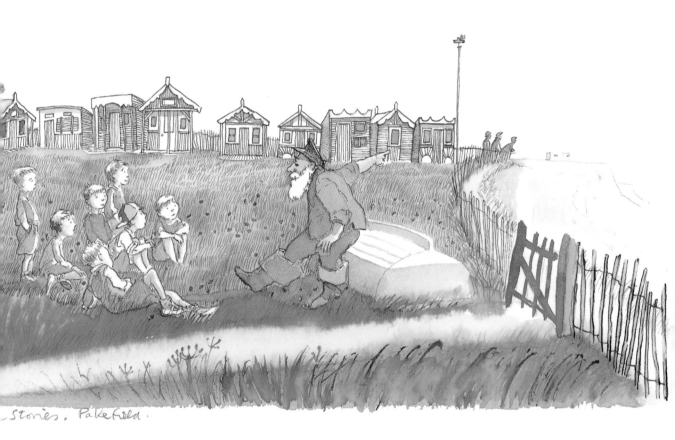

Stories. Pakefield.

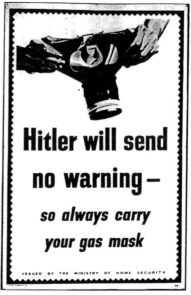

Hitler will send
no warning –
*so always carry
your gas mask*

ISSUED BY THE MINISTRY OF HOME SECURITY

*Children labelled and equipped with
a gas mask each and their favourite
toy at the railway station on their
way to evacuation.*

A WARTIME CHILDHOOD

Lowestoft's population was reduced by two-thirds when most of the
children and many of the mums were evacuated. Some went to stay
with relatives in safer inland towns and villages, but many children
were sent to distant places and spent the years of the war with people
they had never seen before. I was too young to go.

On June 2nd 1940, 2,969 children left in five special trains. 'Danger
of Invasion' posters were pasted up everywhere, and all people not
needed for the running of the town were advised to leave for a safer
place. Many refused to go, including, of course, our mum. But she
did send brother Pud to stay with our granny who ran a pub in rural
Norfolk. He stuck it for a month or two, then sniffed out a fish lorry
and got a lift back to Lowestoft fish market and a bus home. 'What
on earth are you doing home?' said our mum. 'I want to go fishing,'
replied Pud. 'Well, that's that,' said Mum, 'if we are going to be blown
up, we'll all be blown up together!'

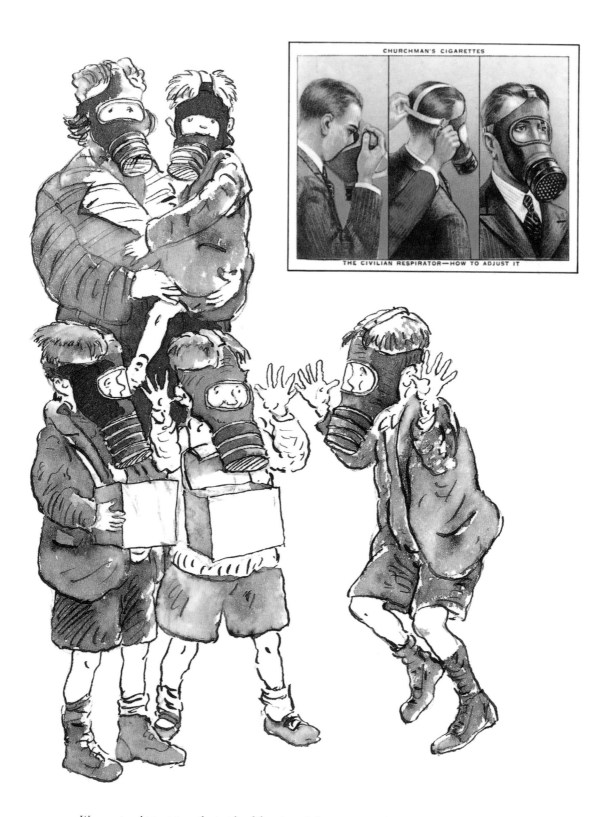

CHURCHMAN'S CIGARETTES

THE CIVILIAN RESPIRATOR—HOW TO ADJUST IT

We were taught to spit on the inside of the mica window to prevent it misting up.
Gas masks were good for rude noises and fogged up anyway.

JUNKERS AND BUTTERFLIES

Because I was only eighteen months old when the war began, I had no memory of a world at peace. I thought the madness and mayhem around me was normal. The dads of all my childhood friends were away in the war so my having no dad around also seemed normal. We grew up as a tribe of children, in and out of each other's houses, learning from our older brothers and sisters, in a world of soldiers and sailors who, our mums knew, would always keep an eye out for us and make sure we came to no harm.

Although the fields and woods teemed with butterflies and birds, our skies and minds were full of planes. More than sixty thousand sailors moved into Lowestoft as the naval base grew. Thousands of sailors strolling along the sea front was too good a target to miss, and there were many dive bomber raids. Usually there was no warning of attack – just a roaring engine from low cloud, a couple of loud 'crumps' and a hail of machine-gun fire. Then, as the dust began to settle and the raider was escaping back over the North Sea, the warning wail of the siren would begin.

Lowestoft's worst raid was on a day of snow, just before dusk. One lone raider loomed out of the cloud above the main street and dropped four bombs onto shops and a crowded restaurant. Seventy people were killed and more than a hundred injured.

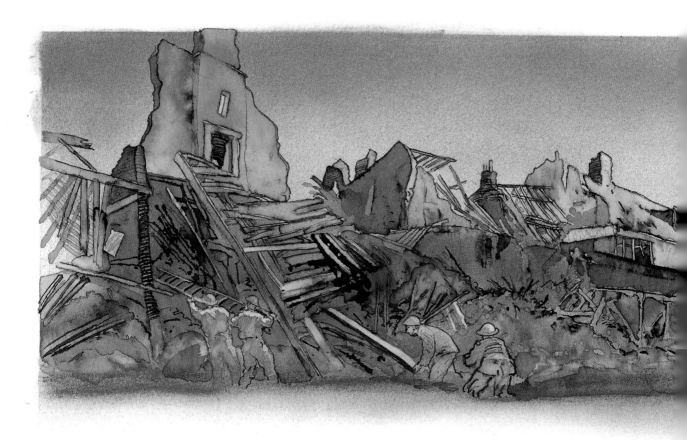

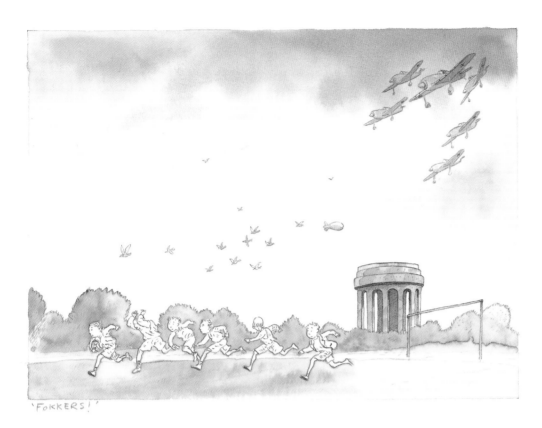

'FOKKERS!'

'One afternoon we children were mucking about with a football on the recreation ground, or "Rec", as we called it. Jack, the oldest of the Botwright brothers, shouted "Fokkers!" We ran like rabbits for the slip trenches under the trees. Twelve Fokker Wulfes swooped out of the sky without warning and flew the whole length of the town spraying cannon shells.'

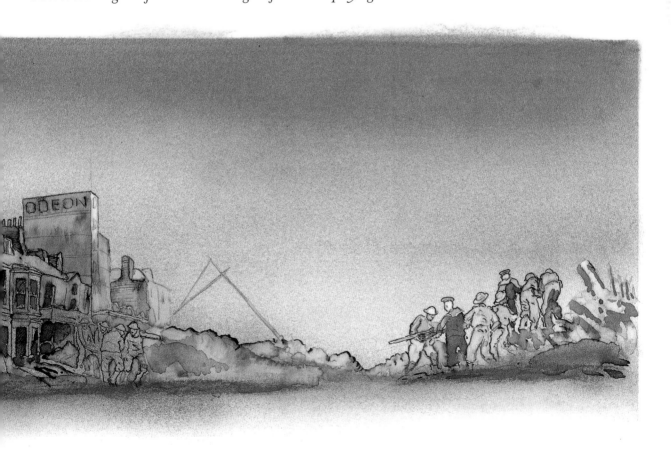

WAR GAMES

As I got older, my world stretched along the London road to Hill Green. Why it was called Hill Green is a mystery. It was just the opposite. It was a hole in the ground, an old gravel pit. In the daytime, the Hill Green shelter became our favourite place to play. Its grassy slopes, covered in spring and summer with wild flowers, were Wild West mountains from which we could swoop down onto the plains and attack the girls, the 'settlers' playing 'house' in the abandoned Builders' Yard.

For some reason, we always liked to be the Indians. Cowboys were so clean and broke into songs and yodels. Also, we wanted to be the pirates, the smugglers, the highwaymen, the cut-throats every time, and never the 'goodies'. We played 'British and Germans' from time to time, but no one would be 'the Germans', so we couldn't indulge in the hand-to-hand grappling that we enjoyed. We had to be satisfied with long-range sniping at imaginary foes or a passing old lady. 'Dive-bombing', with arms outstretched, thumbs firing and engines screaming, was a favourite with us and very unpopular with old ladies. But none of us would ever 'be the Germans'.

'One result of the bombing was that millions of seeds would be blown out of gardens and showered around the district. The following spring and summer, piles of rubble burst into bloom. Marigolds, irises and, best of all, potatoes sprouted everywhere.'

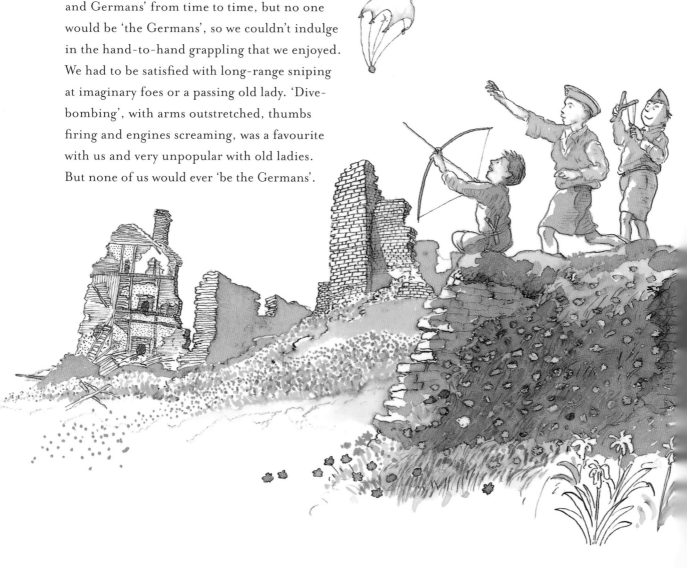

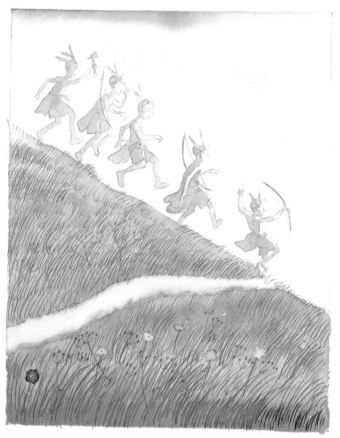

'Our trails criss-crossed the landscape of childhood. We galloped Indian file through sage brush and tumbleweed, one hand holding an invisible rein and the other slapping the seat of our trousers.'

'Liquorice Comforts were my favourite sweets. If you licked them you could war paint yourself. When all the outer colour had been sucked off, we blacked out our teeth with the liquorice centres.'

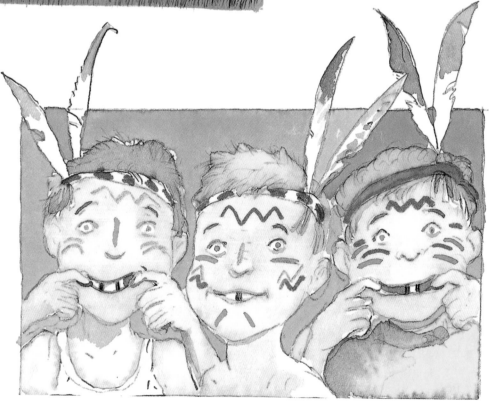

END OF THE WAR

As the war dragged on towards its end, enemy prisoners of war became a familiar sight, working on the local farms. The Italian prisoners were particularly friendly and we boys often played football with them when they had finished work for the day. We were playing football with the 'enemy' while the men of our village were still overseas in the war.

Our cousin, Gwen, married a German PoW as the war ended and went to live in Germany. A year later they came back for a visit in a Messerschmitt 'bubble car'. It looked like a Messerschmitt fighter plane cockpit on three wheels without the wings and black Nazi crosses.

BELOW: *We didn't realise at the time but, looking back at our football games with the prisoners of war, there were touching echoes of the First World War games during the Christmas truce.*

'So it was true, all the things the grown ups had said during the dark days. Now the war was over everything would be all right, there'll be blue birds over the white cliffs, not barrage balloons. And men with rainbows on their chests would come home. And the memory of those who passed through our village on the way to war will remain forever with the ghosts of us children in the fields and woods of long ago.'

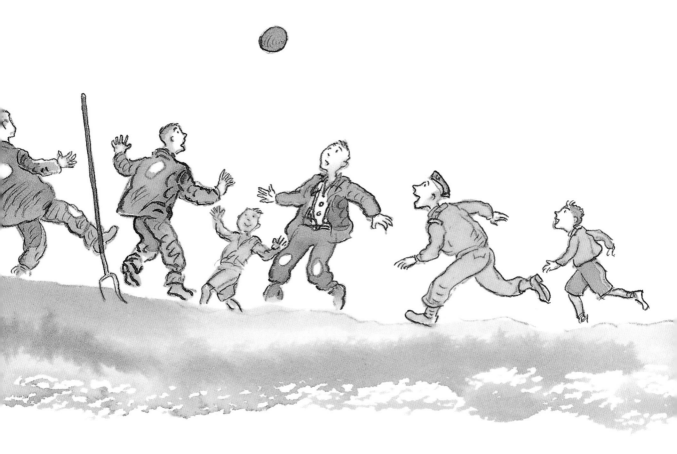

The best surprise of my career to date has been the success of *War Boy*. It was only the persistence of the publisher Colin Webb at Pavilion that made me write down stories I thought would only be of interest to my family. And yet it has touched something in children, many of whom have written to me talking about the experiences of their own family members during the war. It has led to teachers working with the children on school projects throughout the country. There is now a 'War Boy Walk' around my home village of Pakefield. Starting at the old shop, illustrated signs lead from location to location as depicted in the book, to the Church, past the War Memorial and along the cliffs and other trails of my childhood.

While writing *War Boy*, I compared my memories with those of older members of my family. I was struck by the number of aunties I had. Loads of them. But no uncles. Why? The First World War. A generation of men were missing, and the old ladies dressed in black who had worried me as a toddler were, of course, widows of that lost generation. Walking past the War Memorial on my paper round was a daily reminder. So many names. I wanted to tell their story – so I wrote *War Game*.

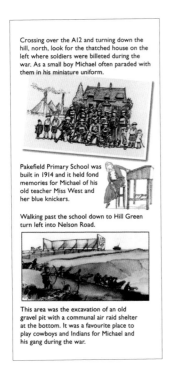

Crossing over the A12 and turning down the hill, north, look for the thatched house on the left where soldiers were billeted during the war. As a small boy Michael often paraded with them in his miniature uniform.

Pakefield Primary School was built in 1914 and it held fond memories for Michael of his old teacher Miss West and her blue knickers.

Walking past the school down to Hill Green turn left into Nelson Road.

This area was the excavation of an old gravel pit with a communal air raid shelter at the bottom. It was a favourite place to play cowboys and Indians for Michael and his gang during the war.

WAR BOY

WALK

As you set off on the 'War Boy Walk,' you are stepping back in time to the 1940's through the childhood eyes of the Pakefield author, Michael Foreman who was born in 1938.

The walk describes sites and scenes of Pakefield life during the Second World War. You will also learn about other parts of a fascinating village called Pakefield.

Continue along Pakefield Street to Forge Cottage, which was the home of the village blacksmith until 1939.

Ahead is the Ferini Gallery. This building was once a net store used by local fisherman and then a bicycle shop. Nearly opposite the Gallery is the Trowel and Hammer which is Lowestoft's oldest recorded pub.

Continue to the Jolly Sailors and turn south onto the cliff path to complete the walk at All Saints Road.

Distance approx. 1.7 miles
Waypoint Markers

On the Promoting Pakefield web you can hear Michael Foreman talk about his Pakefield days.

www.promotingpakefield.co.uk

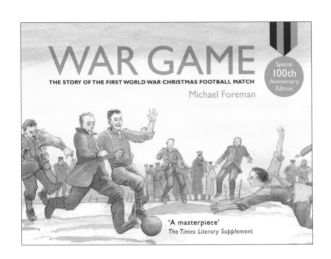

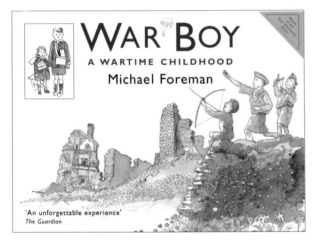

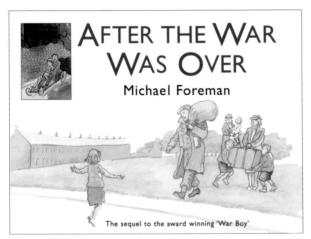

LEFT: *Covers to my autobiographical tales* War Boy *and* After the War Was Over; *and* War Game *– which was a tribute to the lost generation from my village, and their mothers and widows who came for their rations in my mum's shop during the Second World War.*

ABOVE: War Boy *was the winner of the Kate Greenaway Medal in 1989. I was to awarded the medal again in 1982 for* Long Neck *and* Thunderfoot. War Game *won the Smarties Gold Award in 1993 and the animated film won several awards around the world including a BAFTA.*

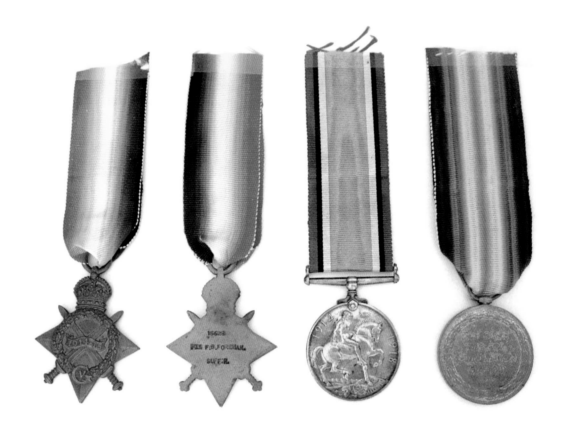

IN MEMORY OF MY UNCLES, WHO DIED IN THE GREAT WAR.

WILLIAM JAMES FOREMAN, KILLED AGED 18

FREDERICK BENJAMIN FOREMAN, KILLED AGED 20

WILLIAM HENRY GODDARD, KILLED AGED 20

LACY CHRISTMAS GODDARD,
DIED OF WOUNDS CHRISTMAS DAY 1918 AGED 24

War Game

My granddad died before I was born. He was the call out man for
the Pakefield Lifeboat and had a long pole for knocking on bedroom
windows to rouse the crew – as of course, nobody had a telephone at
home. He borrowed horses from the clifftop farm to haul the lifeboat
up and down the cliff and across the beach. He had three sons,
William, Frederick and Walter. The names of William and Frederick
are on the village First World War Memorial. I always thought that
my dad, Walter, had been too young to be in the War but, in fact, he
lied about his age and joined the army in 1917, aged 17. He was in
France in the trenches for long enough to contract the early stages of
tuberculosis, and emerged from the War, as my older brother says, 'a
broken man'. He worked for a while as a crane driver for the railway at
the Lowestoft Docks, but then spent more and more time in and out
of hospital and was virtually confined to bed, at home, for the
last two years of his life. On the days when he felt well enough, dad
would teach my brother Pud to fish with rod and line from the beach.
This has been handed down through the generations of Foremans.
Dad died a month before I was born. He was aged 38.

War Game is an attempt to honour all those young men who left their
towns and villages to be part of the great and terrible adventure of the
First World War. To tell the story of the entire war was beyond me.
I concentrated on the 'opening chapter' – from football on the village
green to football in No-Man's-Land during the Christmas truce. With
a mixture of duty and adventure, the village lads 'joined up' and the
book follows them through their training and travels to the Front.
Football gave a rounded shape to the story.

LEFT: *Two brothers walked out of my grandfather's little Suffolk cottage amongst the
hollyhocks and went to war. Their names are on the village War Memorial. Two other
young men, my mother's brothers, left Granny's Norfolk village pub and went to war.
Their names are on another War Memorial. There are no photographs of these young men.
They didn't live long enough to have children. They left just four names amid a multitude.*

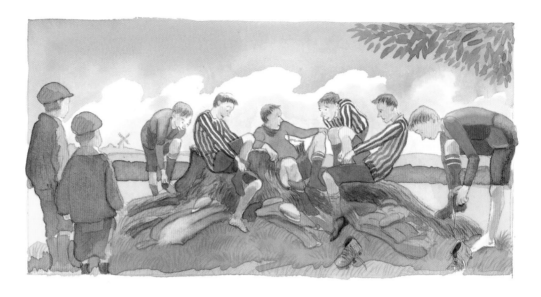

'The two teams changed and joked together. "We'll come back and beat you after the war," laughed one of the opposing team as they began their walk back to their village five miles away.'

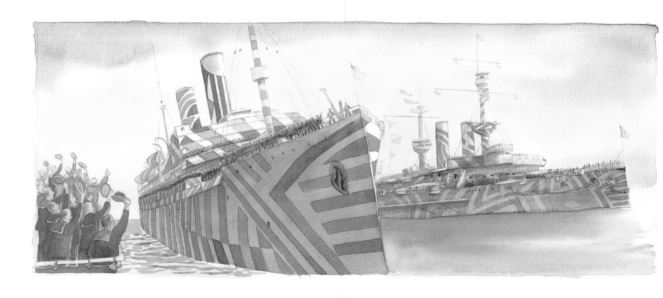

'The whole of Southampton turned out to see them off. Thousands of sailors cheered and waved their caps from destroyers in Southampton Water.'

All illustrations, these pages and overleaf, from War Game.

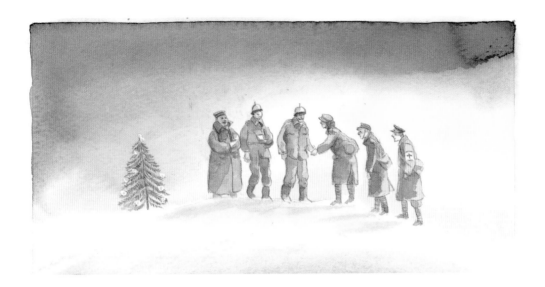

'A small group of men from each side, unarmed, joined them. They all shook hands. One of the Germans spoke good English and said he hoped the war would end soon because he wanted to return to his job as a taxi driver in Birmingham.'

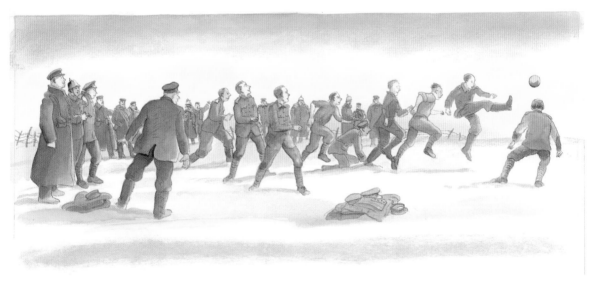

'Immediately a vast, fast and furious football match was underway. Goals were marked by caps. Freddie, of course, was in one goal and a huge German in the other.'

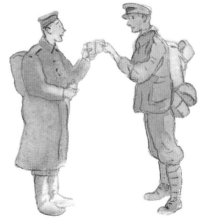

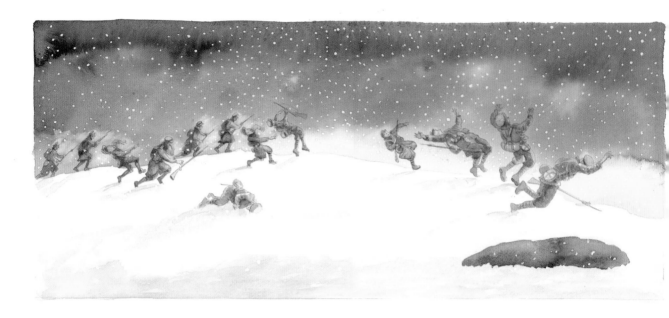

'They were on the attack. Running in a line, Will in a centre forward position, Lacey to his left, young Billy on the wing.

Suddenly they all seemed to be tackled at once. The whole line went down. Earth and sky turned over, and Will found himself in a shell hole staring at the sky. Then everything went black.'

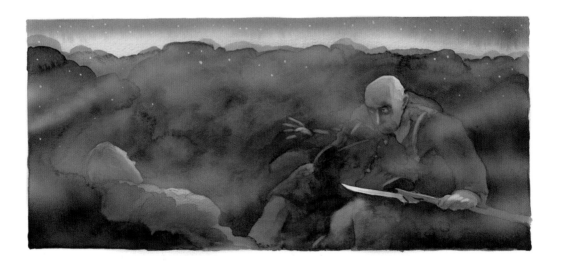

'Slowly the blackness cleared and Will could see the hazy sky once more. Bits of him felt hot and other bits felt very cold. He couldn't move his legs. He heard a slight movement. There was someone else in the shell hole.

Will dimly recognized the gleam of a fixed bayonet and the outline of a German.'

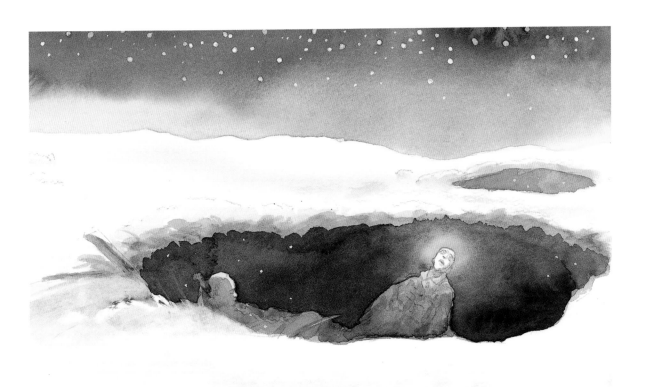

'Later he saw a pale ball of gold in the misty sky. "There's a ball in Heaven,"
he thought. 'Thank God. We'll all have a game when this nightmare's over.'

　　At home when he had a bad dream he knew that if he opened his eyes, the bad
dream would end. But here, his eyes were already open.

　　Perhaps if he closed them, the nightmare would end.'

'He closed his eyes.'

After the War was Over

Of course, when I had finished *War Boy* my sons said 'O.K. But what happened next?' So I did *After the War Was Over* which starts the day after *Way Boy* ends. It begins on the day of the great Victory Party, a day of flags and dancing and real hope for the future. Hope for a different, peaceful world. When I was a little boy, living by a beach full of mines and a sea out of reach, and watching soldiers leaving for 'overseas', I thought the war would last forever. Then, as the war came to an end and ships were no longer

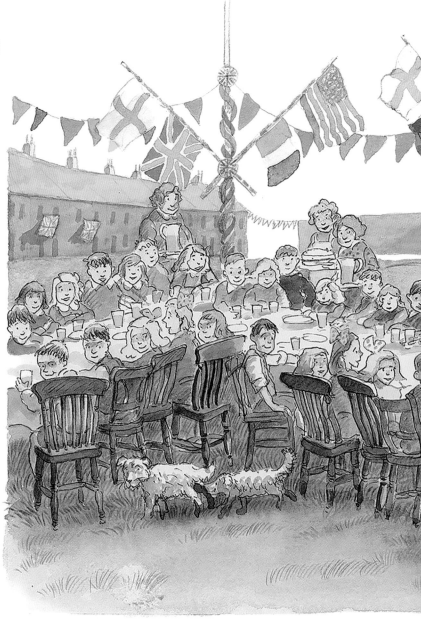

'Brother Ivan wrote to us and sent the occasional photograph of himself and his mates standing outside tents with the pyramids far away in the distance.'

being sunk by submarines, bananas, grapes and amazing pomegranates began to arrive in our shop. I remember the day the first box of bananas arrived. I had seen a picture of a banana but didn't know if it was as big as a marrow, or as small as a pea. The box was 5 feet long. 'Wow!' I thought, 'even bigger than a giant marrow!' 'Overseas' had changed from dangerous to exotic. My brother, Ivan, came home from the army with a bedspread covered in palm trees and pyramids. I longed to visit the countries these wonders came from. For me, the sea did not separate countries, it joined them. The cold North Sea could be my magic carpet to the world.

'It was summer, 1945. The war was over. The victory bonfires blazed on the village green and the embers remained hot enough for days to bake potatoes.'

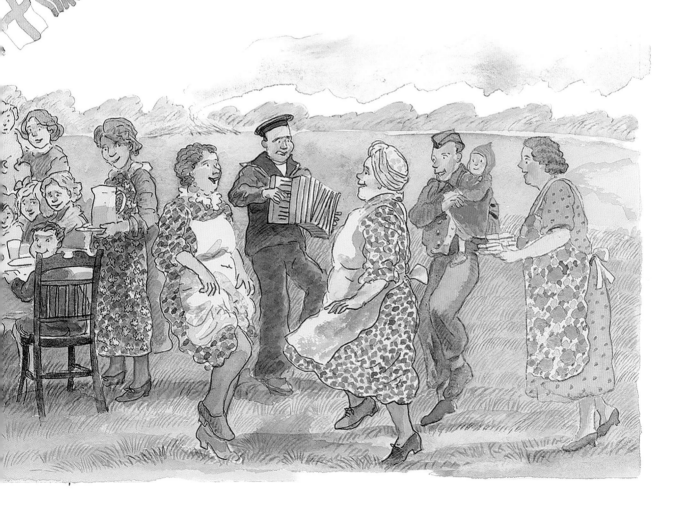

'The cliff path in spring and summer buzzed and shimmered with bugs and beetles and chirruping grasshoppers. There were butterflies in great numbers: Red Admirals, Painted Ladies, Orange Tips, Clouded Yellows, spectacular Peacocks and the modest Common Blue. Like fluttering flakes of blue sky . . . There were lacewings and stoneflies, and dragonflies like green camouflaged bombers. As we lay in the grass, we were dive-bombed by hornets and sawflies, digger wasps and bees. Red ants and black ants surrounded and attacked us like Lilliputian armies.'

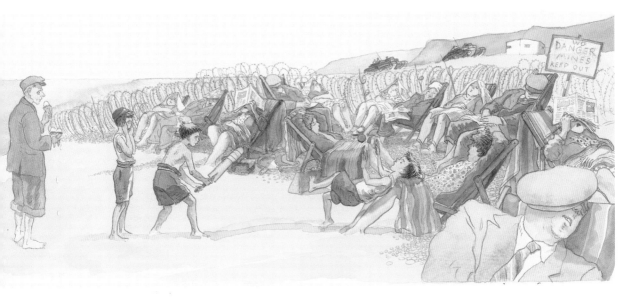

'Grannies and granddads, aunts and uncles, mums and dads, packed onto a tiny patch of beach, and beyond the wire, mile after mile of sand and shingle stuffed with mines and barbed wire.'

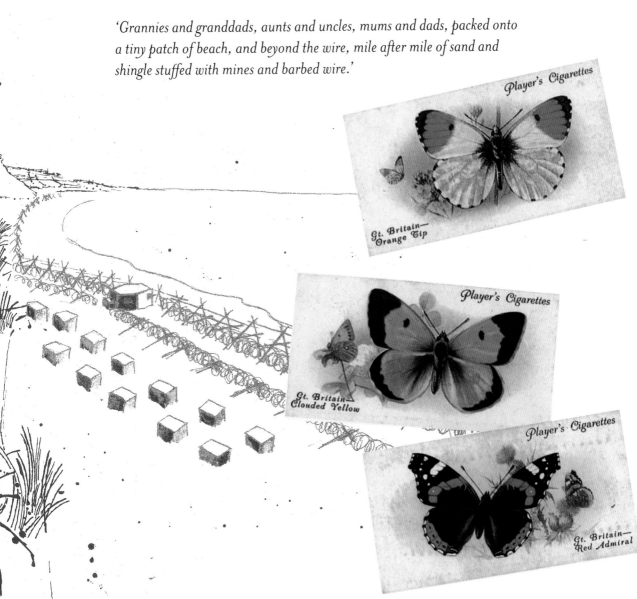

Player's Cigarettes

Gt. Britain—
Orange Tip

Player's Cigarettes

Gt. Britain—
Clouded Yellow

Player's Cigarettes

Gt. Britain—
Red Admiral

I didn't have any books. There were none in the house except the family Bible, which was a Sunday School prize awarded to my mum when she was a little girl. But in our shop we sold newspapers, magazines and comics. I read them all. One of my favourite comics was *Film Fun*, which had real film stars in the comic strips and was printed in black and white. Laurel and Hardy were always on the cover and usually ended up having a huge meal of bangers and mash on a silver dish. I also liked *The Wizard*, *Hotspur* and *Rover*, with their longer stories of heroic boys and dogs and secret agents.

One of my earliest memories is of lying on the floor in front of the kitchen fire, drawing. After the war, paper was in short supply but

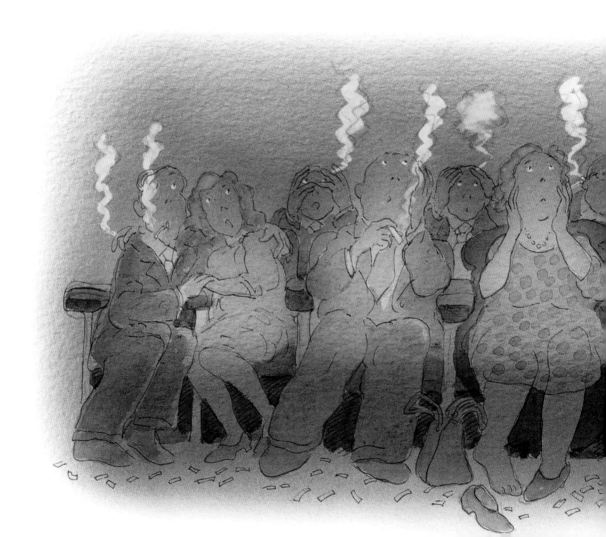

the large biscuit tins delivered to my mum's shop were lined with white paper. The tins were about twelve inches square, so unfolded the paper would be four feet long. Perfect for drawings of marching soldiers and convoys of tanks – the village traffic of my childhood. I used to lie on the floor in front of the fire and draw for hours. We had the *Daily Mirror* for the news and the *Daily Express* because I liked to copy Rupert Bear.

We loved all things American. All our movie heroes – cowboys, Indians, even Robin Hood and his merry men – had American accents. But we didn't like them singing! My favourite films were pirate films because there was always a feast where they ate all kinds of exotic fruit, had bad table manners and a good time.

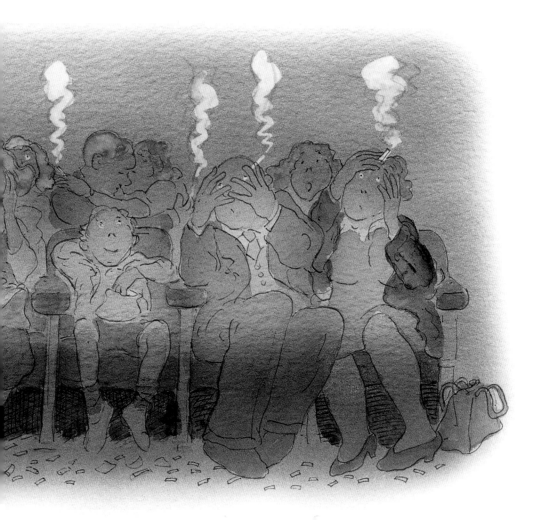

TOM HUDSON – THE MAN WHO CHANGED MY LIFE

One day, I had a new customer on my newspaper round. He came to the
door as I opened the gate. He said he had just arrived in the town from
Yorkshire, and asked me if there was clay in the local cliffs. I said there
was and we used to dig it out and make model tanks and planes from
it. We baked them hard in our mothers' ovens then painted them.

The new customer, Tom Hudson, asked me to bring a bucket of
clay to the Art School, where he was a teacher. I knew nothing
about the Art School except that it was above the local Youth Club,
around the corner from my barber. When I took the clay to Mr
Hudson, he decided it was too gritty for modelling, or sculpture as
he called it, but suggested I join a Saturday class he was starting for
school children. It was free, so I did.

He took us sketching on the first day. He took us to the very church orchard I had
been caught scrumping in a few years before. Sketching those gnarled old apple trees
was such fun, I couldn't think why I had never done it before. Drawing had always
been an indoor thing, flat out on the floor in front of the fire, making things up.

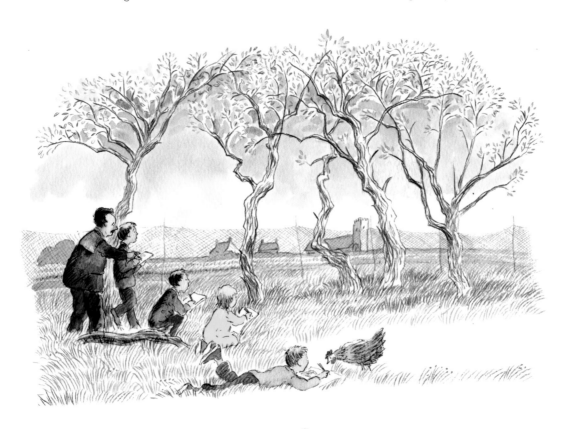

Because I couldn't ride a bike I delivered the newspapers to houses nearest the shop. Other paperboys went farther afield on their bikes. If I had been able to ride a bike, I wouldn't have had the paper round nearest the shop. I wouldn't have met Tom Hudson. I would never have gone to Art School. If I hadn't been able to do this, I'm sure I'd have become, like many of the other local boys, a fisherman.

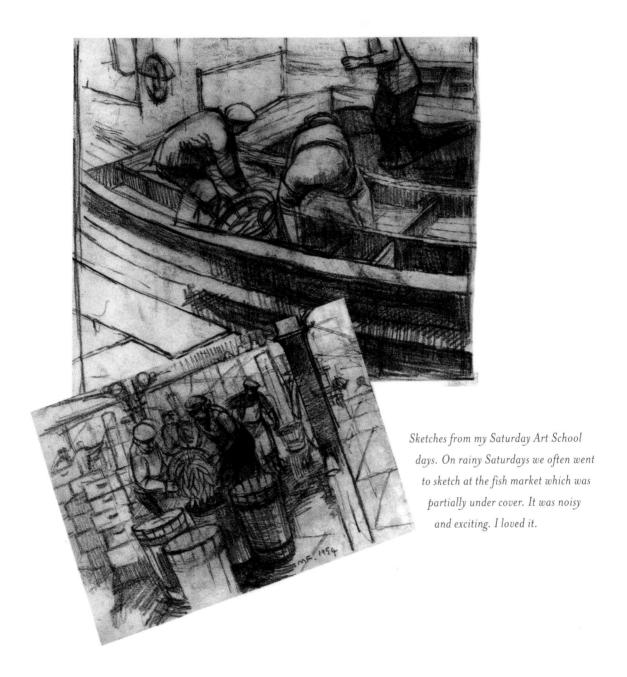

Sketches from my Saturday Art School days. On rainy Saturdays we often went to sketch at the fish market which was partially under cover. It was noisy and exciting. I loved it.

At about this time we got a new headmaster. It was his first job as a headmaster and he was full of new ideas. He walked on to the stage on his first morning wearing his black academic gown. We were shocked. We had never seen anyone wear such a thing except in Will Hay comedy films. This man meant business. He was Michael Duane.

He wanted to brighten the place up. He asked the art teacher, Mr Nicholls, to select a couple of boys to design and paint a mural in the entrance to the school. Mr Nicholls picked me and another boy, Brian Gifford. We did the mural of the local fishing industry: fishing boats, nets, etc. The headmaster realized that I was good at not much beside art. He knew I was going to the Art School on Saturdays, and he arranged for me to go there two afternoons a week as well.

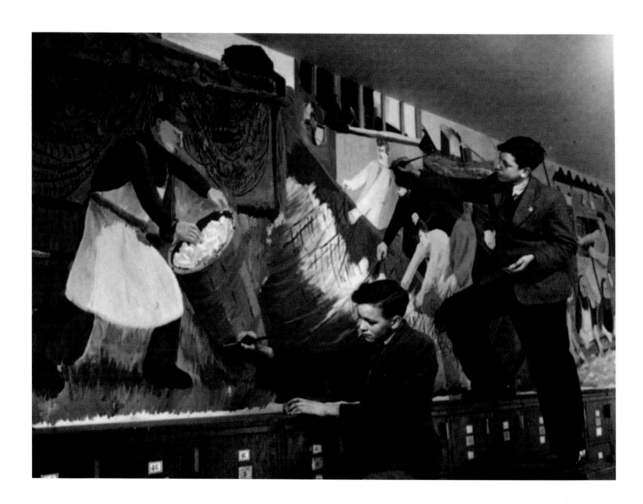

Me and Brian Gifford (right) painting the mural. Brian joined the RAF after leaving school.

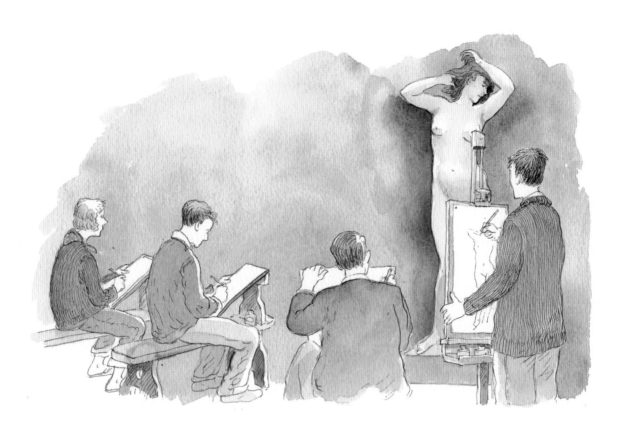

Life Drawing classes, illustration from After the War Was Over.

LOWESTOFT ART SCHOOL

As soon as I was fifteen I could leave school and go to Art School.
I was lucky. I was the youngest son. Pud and Ivan, my big brothers
were both working and earning enough to keep themselves and give
some to our mum. Between them they could afford for me to go to Art
School. Of course I continued with my paper round and helped out
in the shop, as well as having a holiday job at the Birds Eye Factory.

On my first day at Art School I went into a drawing studio with the
other students, who were two or three years older than me. A lady
came in and took off all her clothes. She stood on a little box in the
middle of the room. The students began to draw. I stood behind an
easel in the far corner and sharpened my pencil. It kept breaking.

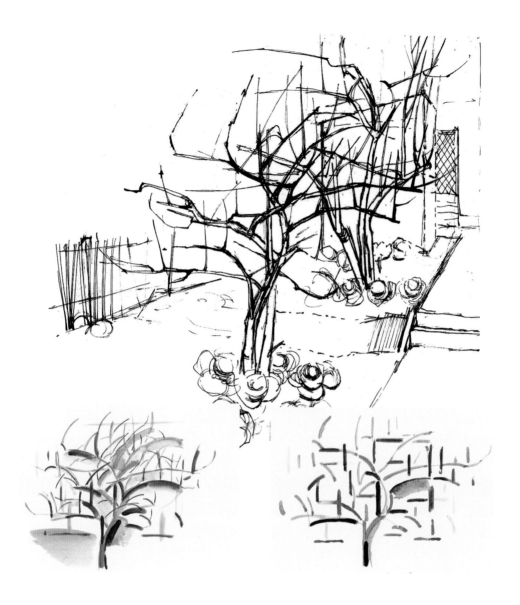

I was fortunate to go to an old-time traditional Art School. It was small and provincial. We were told to draw the world around us. The fish market, the slaughterhouse, the shipyard, the same little orchard of apple trees. In spring, summer, autumn and winter. Over and over. We didn't question it. We loved it. The habit of drawing the world around me stuck.

We had to draw from the skeleton for hours, day after day, then from the human form (the lovely voluptuous Sadie). We studied anatomy and perspective. Tom Hudson took us, step by step, into abstraction and back again. We learned the basic structure and relationship of natural forms. The bend of a branch, the curl of a wave, the curve of a thigh. He also introduced us to Dylan Thomas. Listening to Richard Burton reading *Under Milk Wood* . . . I had never heard such rolling, rhythmic language before.

While I was a student in Lowestoft, I did some work for the local paper, The Journal. Cartoons of local events, and drawings for the advertisements of a music shop. I got thirty shillings from the shop, £1 for the cartoons.

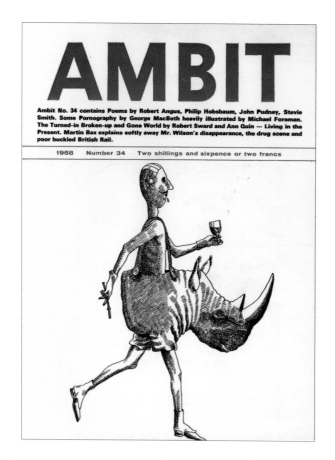

ABOVE AND ABOVE RIGHT: *Two covers designed by me.*

THE BIG CITY

After completing the Painting Course at Lowestoft,
I moved to London to study Commercial Art at
St Martin's School of Art. There, I met and married
a fellow student, Janet Charters, and a year later we
had a beautiful baby, Mark.

Mark was born in a ward with two other babies. One
was Damon Hill, whose father, Graham, was Formula I
World Champion at the time. The other baby was Tim
Bax, whose father, Martin, was a young doctor who in
his spare time had started a literary magazine called
Ambit. He was publishing it from his front room and
needed artists to illustrate the poems and short stories.

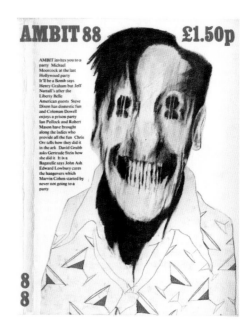

ABOVE: *Cover by Mark Foreman, my eldest son.*
Mark writes and illustrates his own books for
UK and US publishers and, since his days at the
Royal College, has contributed many drawings
for Ambit *magazine.*

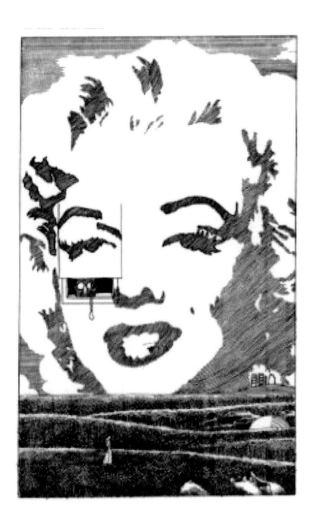

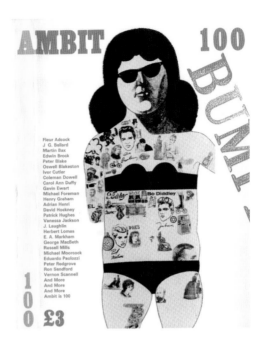

By Sir Peter Blake. Peter gave me drawings for my very first **Ambit** *and continued until my final issue.*

There was no money to pay artists, he said, but would I be the unpaid Art Director? This meant it was my job to get artists to work for nothing.

I had just won a place at the Royal College of Art and turned to my fellow students there to provide drawings and illustrations. They obliged and many continued to do so for the next fifty years, with no fee. Many became successful, some world famous like David Hockney, and two are Knights of the Realm. Martin and I retired from *Ambit* in 2014 but the magazine lives on and has finally moved from Bax's front room!

ABOVE: *Cover by my youngest son, Jack Foreman.*
ABOVE LEFT: *Illustration by me.*

THE ROYAL COLLEGE OF ART

When I stood in the lunch queue on my first day at
the Royal College in 1960, I felt lucky to be in such
a crowd. There was a buzz about the place. The
Graphic Design students wore ties and suits like
Advertising Art Directors from Madison Avenue.
The painters, many of them from the North or
Wales, were all big boots and Woodbines. The
sculpture students were even more butch, especially
the girls. The pretty girls and boys were in Fashion
and Textile Design. There was no illustration
course at the College at that time. It was felt that
there was no longer sufficient demand, and that
the camera had finally taken over. There was,
however, a curious course called Decorative

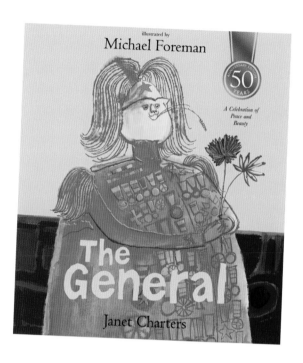

Graphics. This was for people who were too messy to do Graphic
Design. I, and other would-be illustrators, were dumped in this
category. It was fine with me. I just wanted to be there.

Although I did the Decorative Graphics course, I gravitated naturally
towards the Painting students. I found a stairwell leading into the
adjacent Victoria and Albert Museum where I could continue doing
quite large abstract paintings. The stairs led to the restaurant in the
Museum and painting tutors sometimes stopped and discussed the
work with me on their way to coffee. The students got their tea from
the wonderful Mrs Bucket who had a big, shinning tea urn at the
end of the painting school corridor. There was such overcrowding
in the College that some painters worked in the corridor in little
cubicles. Getting tea from Mrs Bucket was like walking through
an ever-changing exhibition. One student caught my eye. He was
working on a small, circular painting. I wanted to buy it for Janet's
birthday and asked him, 'How much?' He grinned and said, 'a fiver'.
I bought it. His name was David Hockney. The 1960s are seen now as
a vintage time at the College. Many of the students came from poor
backgrounds and never expected such a chance. They grabbed it.
Those who became famous were invariably those who worked hardest.

Every Friday night there was a bar party or a dance. New rock and roll bands were springing up and many played at RCA dances before becoming successful. This was the hothouse for the 'Swinging Sixties'. The music, the young fashion designers, photographers, painters, film makers were just about to bloom. Our lodger, Shirley, a sculptor at the College, had a boyfriend, Charlie Watts, who was a drummer with a new, unknown band called 'The Rolling Stones'. I drove Charlie to the BBC for their first appearance on TV and the next day our little street in Fulham was besieged by fans.

With a wife and baby to support I tried to get work doing book covers. First I would need to do some examples to show publishers. Janet and I made up a little story and I did two or three covers for it. Matyas Sarkozi, a Hungarian student and one of the witnesses at our wedding, saw the work and said a neighbour of his was a publisher. He got us invited to tea at the publisher's house. The publisher liked the little story as well as the cover. 'Finish the story,' he said, 'and I will publish the book.' Meanwhile, the publisher gave me some book covers to do. *The General* was published in 1961. It was well reviewed in Britain, but in America was called 'a Communist tract for the nursery'. It was a thinly disguised pacifist fable about the Cold War. A 50th Anniversary edition has recently been published, as well as a Russian edition.

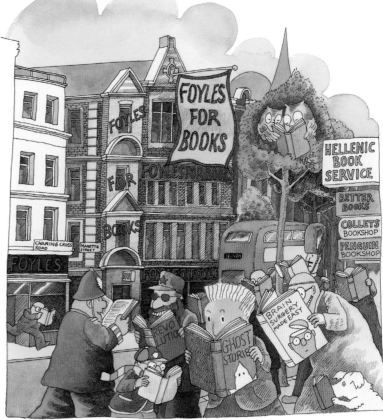

RIGHT: *We were living in a tiny flat above a barber's shop in Soho, just off the Charing Cross Road which, at the time, was the street of bookshops. There I felt the buzz of seeing my work in a bookshop window.*

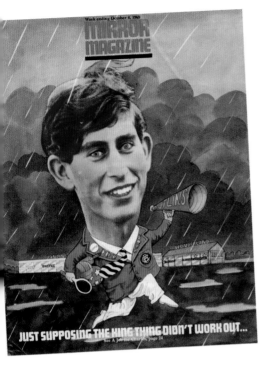

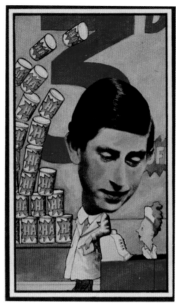

Supermarket Trainee.

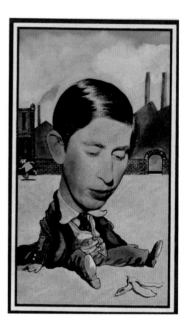

Schoolmaster.

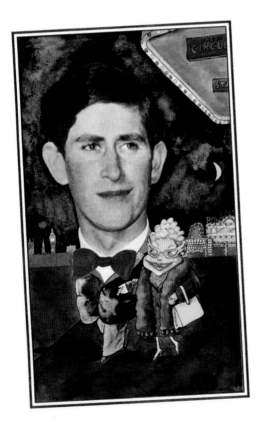

TOP: *Butlins Red Coat.* ABOVE: *Male Escort.*

MAKING ENDS MEET

When I moved to London I went to the local paper, *The Hampstead and Highgate Express* and did drawings for them. Hampstead was stuffed full of artists, but they must have felt too grand to work for the local paper. Here they paid three guineas. Three guineas would buy half a week's food. One day, instead of going up the hill to Hampstead, I went down the hill to Fleet Street to try my luck with the National Newspapers. I began to get work with the *Sunday Mirror*, including a special issue on the job prospects of the young Prince Charles.

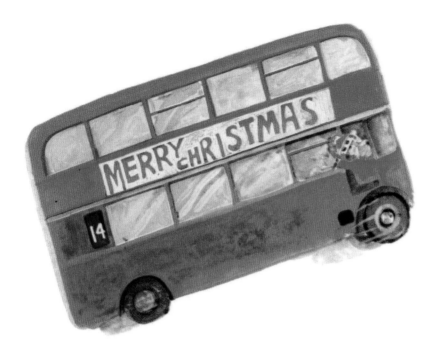

The *Sunday Times* and the *Observer* launched their colour magazines while I was a student at the Royal College. The *Observer* offered me a twelve-month 'retainer' fee to do drawings for them and not for the *Sunday Times*. By the end of the year, the editors realized they hadn't 'got their money's worth' so asked me to write and illustrate a Christmas story for them. As I travelled to the College and back each day on the number 14 bus, I decided this should be the 'vehicle' for my story in which the number 14 comes to the aid of Father Christmas. A year after it was in the magazine it was published as a book, *The Perfect Present*. In 2014, an image from the book was resurrected by the Royal Academy as a Christmas card.

There were some marvellous teachers at the College, particularly for me Edward Bawden and Brian Robb. They had both been war artists, and shared their enormous experience with gentle generosity. We also had visits from the great illustrator Edward Ardizzone. He talked to us individually. He saw I was struggling with a drawing of a horse. 'I will tell you my secret for drawing horses, dear boy. Put 'em behind a bush. Then you need only draw the head on one side of the bush and the tail sticking out the other. You don't have to draw the difficult bits.' From my primary school teacher Pat Palmer to Edward Bawden, I had been blessed with a succession of remarkable teachers who had, one by one, opened doors and new horizons.

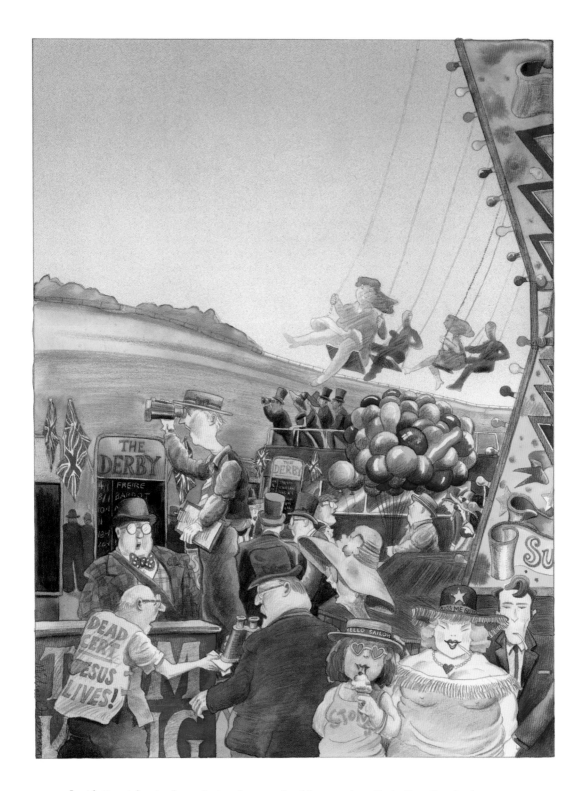

I got better at drawing horses in time for a couple of features about Derby Day. One for the
Illustrated London News *(above) and another for the* Sunday Mirror *which coincided*
with the General Election of 1964 (opposite).

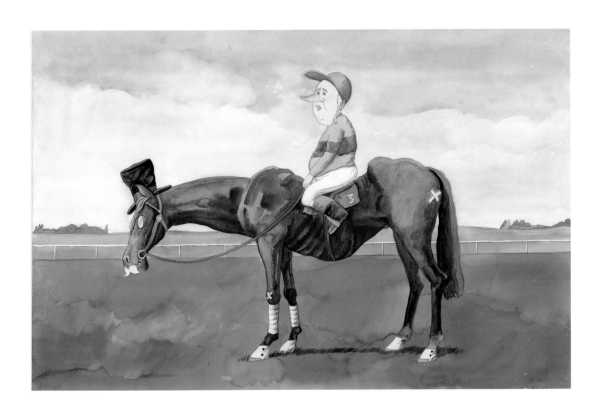

THE TORY. Ridden by E. Heath. Beaten favourite last time out and likely to remain one. Sails through the field in the wet, but often gives impression that right hoof doesn't know what left hoof is doing.

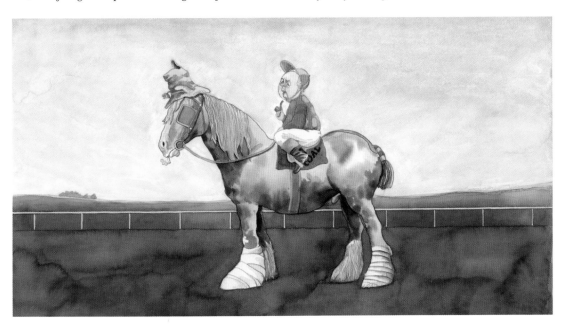

PINK PARADISE. Ridden by H. Wilson. This unfashionably bred colt started in North Country point-to-point and eventually won the Whitehall Stakes. Hopes to run in ever-decreasing circles in effort to end up where he started.

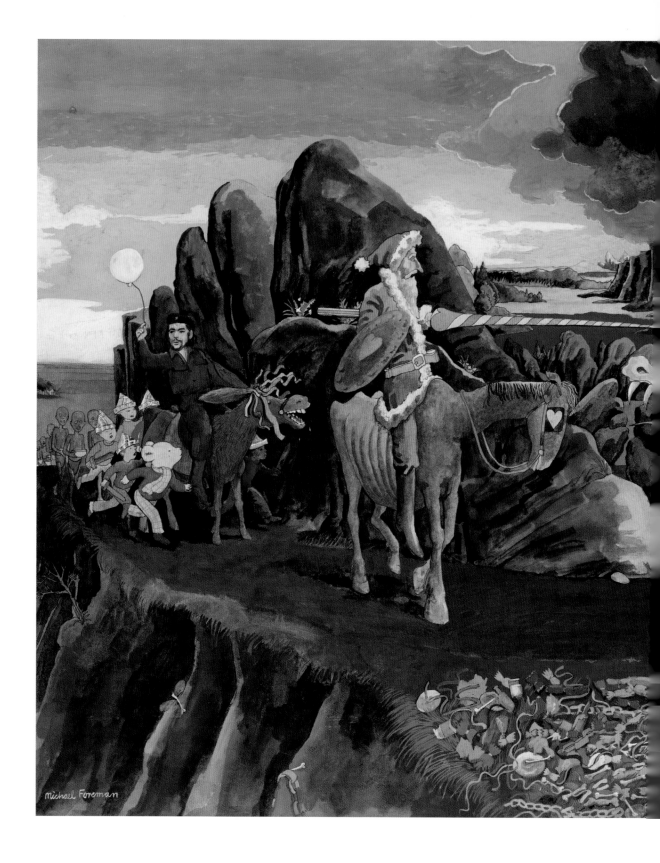

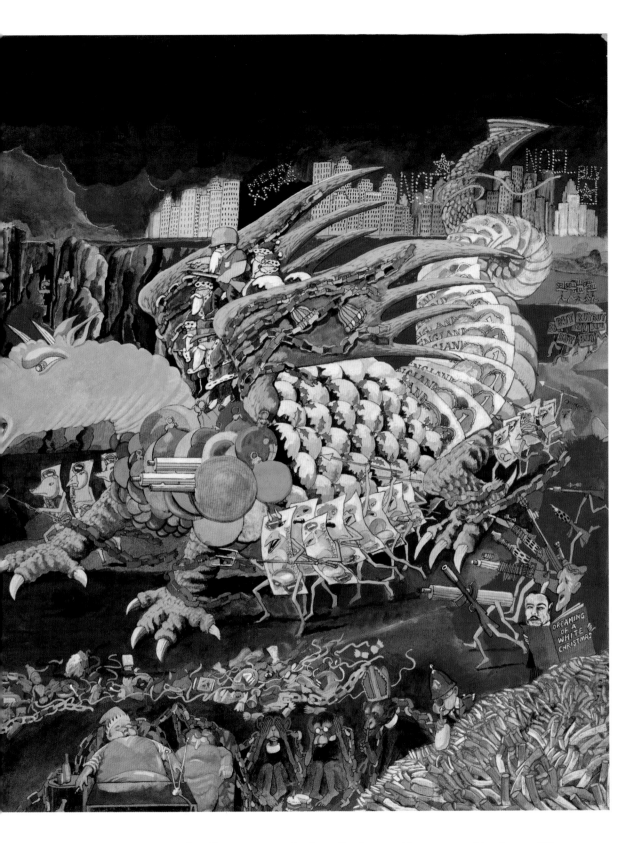

I was asked by Nova *magazine to do a Christmas picture for them. 'Anything you like – just something that says "Happy Christmas" to all our readers.' Santa Claus is my Don Quixote, with Che Guevara as his Sancho Panza and Rupert and the hungry children trying to stem the festive tide of commercialism, couch potatoes, bigotry and fag-ends. Happy Christmas!*

PEOPLE
AND
PLACES

Cornwall Magic

Location and landscape are important elements – characters almost –
in many of my books. Not just landscape, but seascape and the ever-
changing sky give mood and atmosphere, changing colour and drama.
Add weather to the mix and you have a powerful cast of characters
before even thinking of the people, animals, spirits and fantastic
creatures you can introduce.

When I first saw the dramatic landscape of Cornwall, the light
bouncing off the sea, a 'week's weather in a day', I understood why this
had always been a land of myth and legend. I didn't realise that I had
found a land which would inspire quite so many stories of my own.
It was 1961, my second year at the Royal College. We got a £100
advance for *The General* and I bought a car for £80. It was a Talbot, built
the year I was born. One of my teachers at St Martin's, the painter Joe
Tilson, offered us his remote cottage in Cornwall for the summer.
I prayed the old car would get us there. It was the kind of car you had
to encourage up hills by bouncing backwards and forwards in your seat
as you would on a reluctant donkey. We eventually arrived at the tiny
village of Nancledra and collected the key from the village shop. The
narrow road from the village meandered up and up and petered out
in a field. The cottage could only be reached by foot across two more
fields. There was no electricity or gas, and the water had to be fetched
from a well a hundred yards away. Not the place to bring a tiny baby,
but we loved it.

Cornwall had attracted me since childhood. Pop, a sailor from
Mevagissey, had told me of the land of rocky cliffs and smugglers and
giants as if it had been another world. I now found it was. When we
came down from the high moor of the cottage and looked on St Ives
I knew I wanted, some day, to live there. Now I knew why some of my
heroes worked there – Nicholson, Heron, Hilton, Hepworth, Bernard
Leach. We sat on Porthmeor Beach, in front of their studios and
hoped to see them, to be invited to their parties. No such luck.

I returned to Cornwall many times after that first visit and, whatever the weather or season, coming over the crest of Bodmin Moor was like seeing the Promised Land. When we crossed the Hayle river, our cat Tex would leap onto the dashboard, whiskers all a-twitch with excitement.

'That first summer we rented a remote cottage on the moor of Upper Georgia. The nearest pub was the Tinners Arms in Zennor two miles away. When we walked to the pub over the old drover's track, the great blue arc of the Atlantic had, by a trick of the distant haze, a false horizon and a line of fishing boats seemed to be sailing high in the sky. Magic. Cornwall magic.'

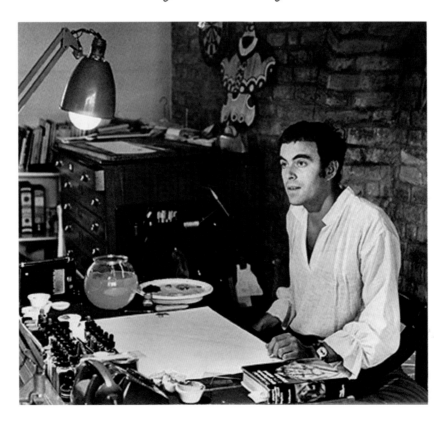

Many years later, in 1983, I had the privilege of buying Ben Nicholson's old house. The garden studio needed rebuilding and we topped it off with a copper dome, echoing the lighthouse on the pier. Nicholson described the view in a letter to Sir Herbert Read on 24th February 1955:

'It's an absurd place . . . v. romantic . . . and with a whole series of different levels from which one sees between rooftops the Atlantic, the Island, St Ives Bay, Godrevy and finally from the top-most "lookout" level slap down into the harbour itself – in the foreground a chapel roof rounded at the nearest end to my terrace.'

RIGHT: *From the balcony of the new studio, the view is even better than in Ben Nicholson's time.*

BELOW: *Our son Ben flying his kite by the pier. The harbour of St Ives is a recurring setting for my stories. Illustration from* Ben's Baby.

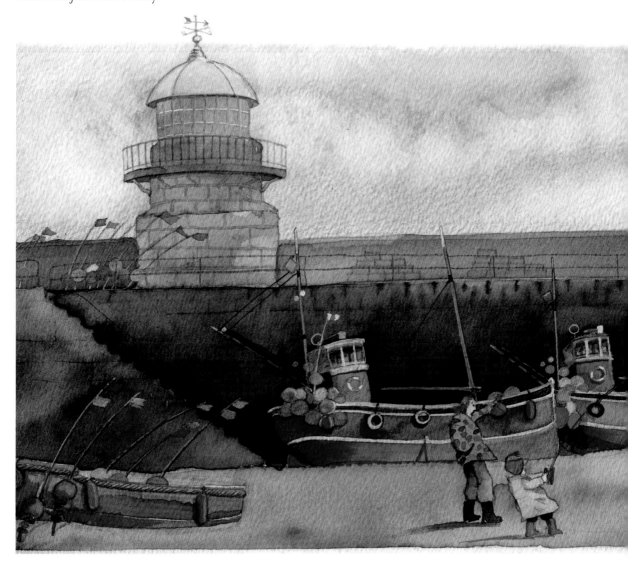

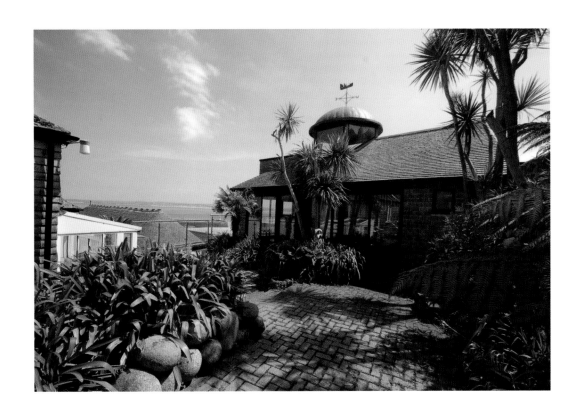

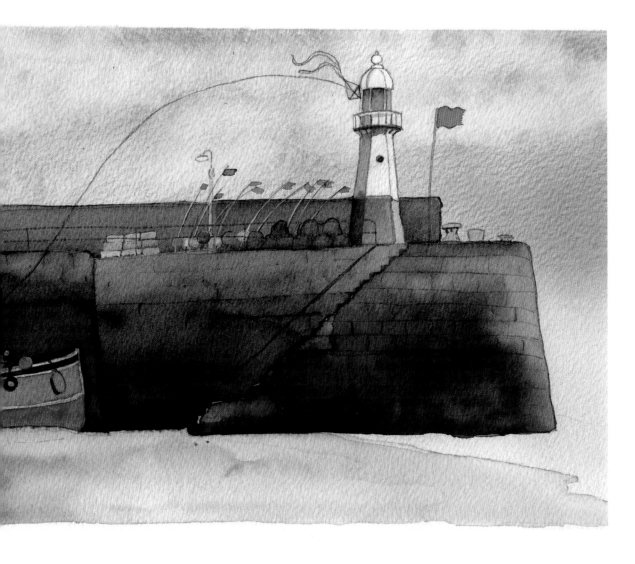

Classic Children's Tales

It is always a privilege to be asked to illustrate a 'classic'. Of course, you can't change the text in any way, but maybe you can show the story in a different, new light; a personal light, something from your own experience. When I worked on a series of classic tales for Pavilion, I drew inspiration from people and places I knew. People and places. Chicken and egg. The teachers who fired my young imagination with tales of Ratty and Mole and Alice and Long John Silver laid the golden eggs, but the eggs needed to find the right places in which to hatch. The Cornish light, dark northern forests and shimmering South Seas spread from my sketchpads onto the pages of the 'Classics'.

THE WIND IN THE WILLOWS

When I was fourteen, our English master, Mr Rudd, discovered that in our class of thirty, not one boy had read *The Wind in the Willows*. The following Friday he brought in his own copy and began to read to us. He was a very hard man, and therefore respected and obeyed by the boys. By the end of the first page, he could have been as soppy as the music teacher. We were enthralled. Less than a year later, I had left school. Apart from a couple of doodlebugs and our one and only sex lesson by the sports master on an afternoon too wet for football, *The Wind in the Willows* on a few Fridays was the most memorable part of my education.

At last — an opportunity to illustrate one of my favourite books from childhood.

As an illustrator I have always been in awe of the version created by Ernest Shepard. Arthur Rackham also did a beauty. So why did I do another? Before I began, I saw some letters written by Kenneth Grahame to his small son Alistair. He referred to the boy as 'Dearest Mouse', and the letters contained the first appearance of the Toad and other characters later to be immortalised in *The Wind in the Willows*. The letters were hand-written on headed notepaper from two hotels in Cornwall: the Fowey Hotel, and the Green Bank Hotel in Falmouth. I was thrilled. I now had a different perspective on the story. Grahame's imagination had been lit by Cornish light, and so was mine.

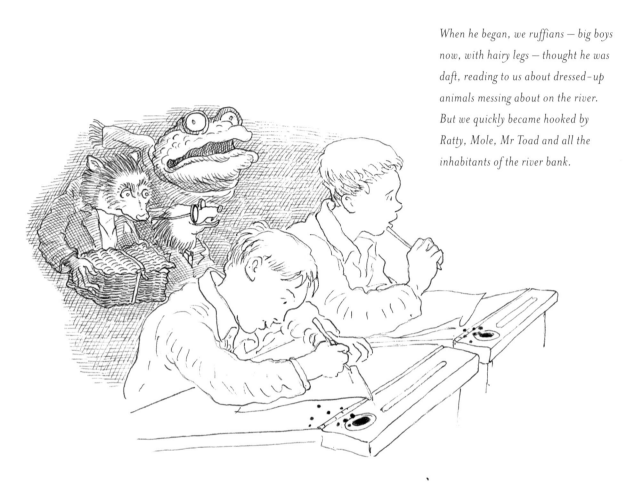

When he began, we ruffians — big boys now, with hairy legs — thought he was daft, reading to us about dressed-up animals messing about on the river. But we quickly became hooked by Ratty, Mole, Mr Toad and all the inhabitants of the river bank.

One particular friend of Mum's was a big sailor from Mevagissey called Pop. He used to tell me tales of Cornwall, a land full of smugglers and seas full of shipwrecks. Pop sometimes took me fishing on the river and, many years later, when illustrating the riverbank in **The Wind in the Willows**, it was these wartime days, fishing for tiddlers, which inspired me.

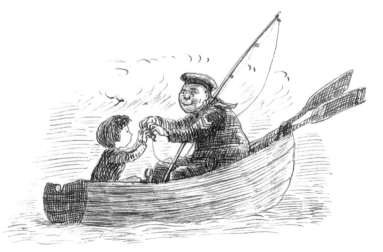

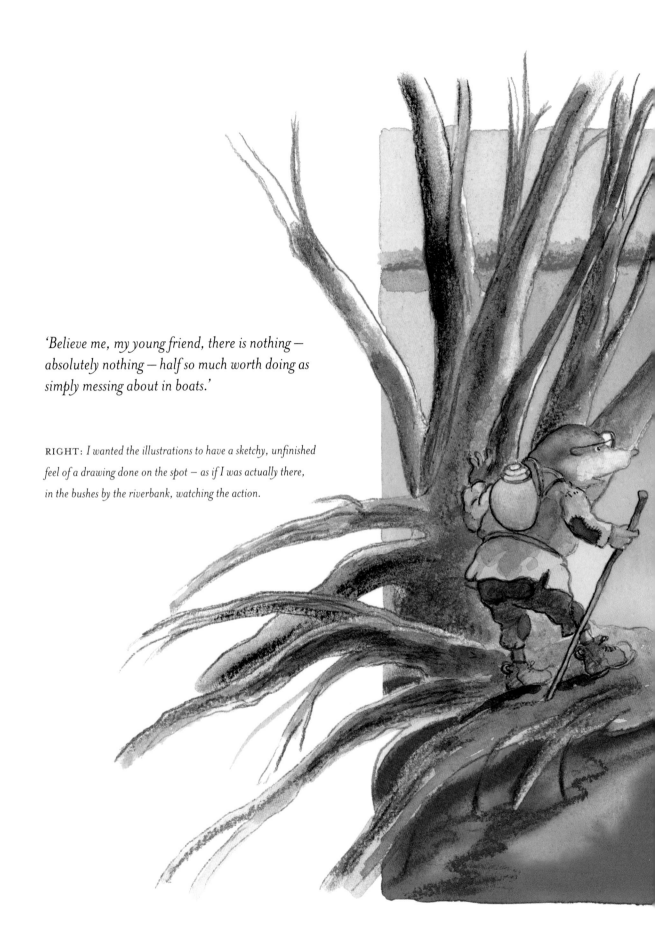

'Believe me, my young friend, there is nothing — absolutely nothing — half so much worth doing as simply messing about in boats.'

RIGHT: *I wanted the illustrations to have a sketchy, unfinished feel of a drawing done on the spot — as if I was actually there, in the bushes by the riverbank, watching the action.*

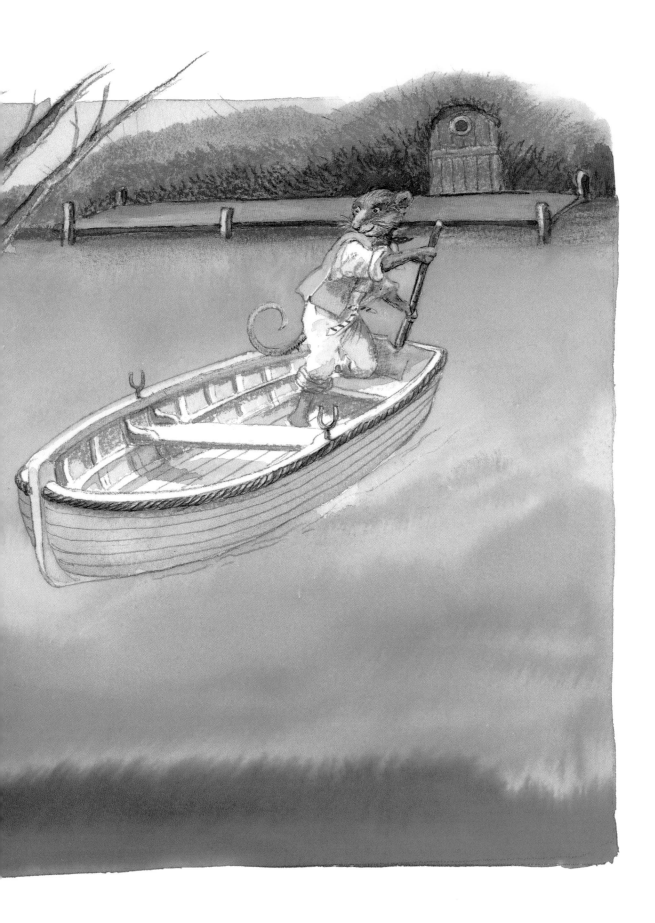

'The Sea Rat continued the history of his latest voyage . . . Spellbound and quivering with excitement, the Water Rat followed the Adventurer league by league, over stormy bays, through crowded roadsteads, across harbour bars on a racing tide, up winding rivers that hid their busy little towns . . .'

BELOW: *The Sea Rat at the harbour in St Ives. The lighthouse at the end of the pier was the inspiration for my studio. This is the original pier, before it was extended and capped with a new domed lighthouse. Buildings are characters also, like the white cottage at the corner of the harbour, with two windows and a door gazing open-mouthed at the view.*

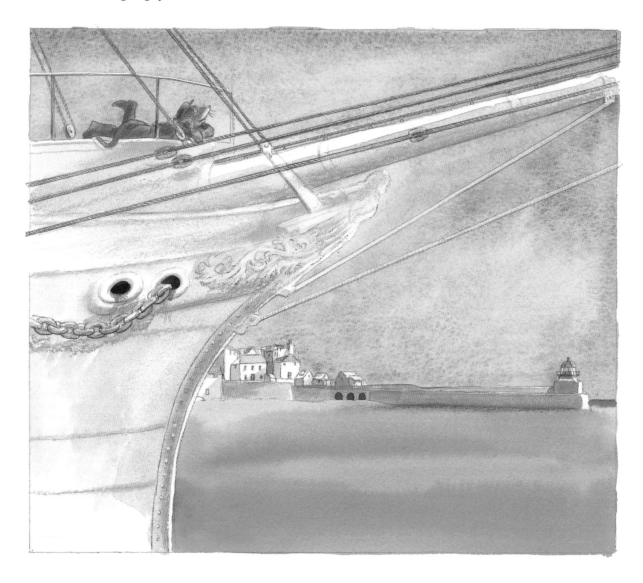

The chapters 'The Piper at the Gates of Dawn' and 'Wayfarers All' are often omitted from modern editions. They are little interludes in the main narrative, but the descriptions of moonlight on water and old haunts transformed by a climbing moon and of Rat bewitched by the tales of the Wayfarer are magnificent. They inspired pictures in my mind and wanderlust in my heart on Friday afternoons long ago.

Like the 'tall story' telling tramps and the old fisherman's yarns of my boyhood, the Sea Rat's tales of Cornwall enthralled and inspired Ratty. I made the pose of all three storytellers very similar, influenced of course by Sir John Everett Millais's 1870 'The Boyhood of Raleigh', which depicts the young Raleigh and his brother captivated by the tales of an old Genoese sailor. The words LAND'S END on a signpost or milestone is an irresistible magnet – drawing the traveller down, down to the West. Even the sun finds it impossible to resist.

BELOW: *Sea Rat introduces Water Rat to the wonders of Cornwall, as Pop the sailor did to me.*

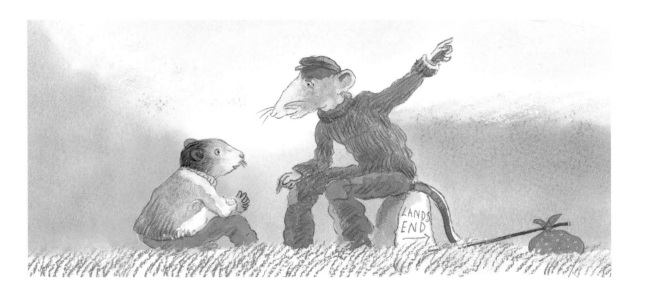

The teacher of the top class at Pakefield Primary School was Oscar Outlaw – a big man who must have been an officer in the war. He had an air of authority which none of us would dream of challenging. He realised that none of us had books at home. It wasn't just because of the shortage of books due to the War; we came from a culture which had no books.

Oscar Outlaw decided to rectify this by reading from his own favourite boyhood books. One day he started reading *Treasure Island*. For me the two most magical words in English literature are 'Treasure Island'. Just to hear those words today gives me the same tingle I felt when I was first introduced to Jim Hawkins, Long John and Ben Gunn all those years ago.

I can see Oscar Outlaw now. Above his desk he was all authority, his great lion head cradled in his hands, elbows on the desk and, between his elbows, the book. But below the desk he was all little boy. His bent knees bounced up and down. His legs were in frantic motion as a duck's legs are below the surface while the body remains calm. Oscar Outlaw was treading water so as not to drown in the excitement of the stories.

OPPOSITE: *This view is based on 'The Sloop' pub on the quayside of St Ives. The window seat is my favourite pub seat in the world.*

LEFT: *From* After the War Was Over.

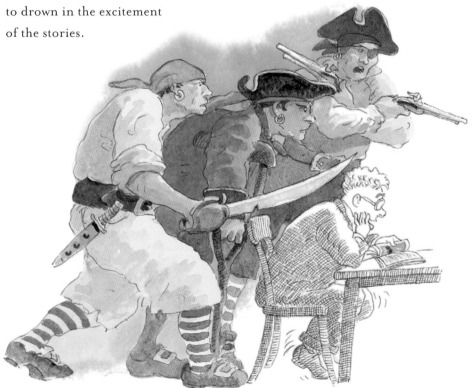

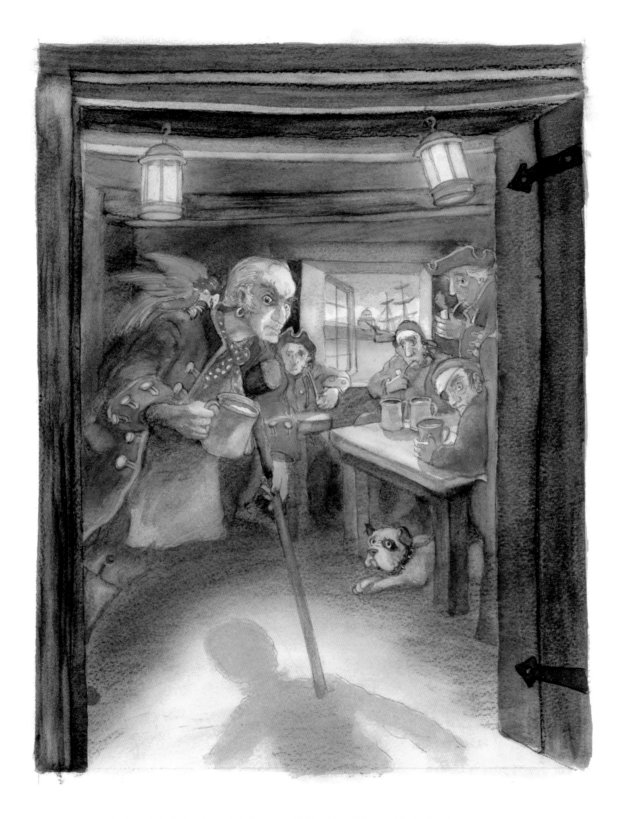

My Long John Silver is modelled on my old friend Phil Moran, Master Mariner and author of our 'Soggy the Bear' books.

'The Hispaniola rolled steadily, dipping her bowsprit every now and then
with a whiff of spray . . . everyone was in the bravest spirits because we were
now so near an end to the first part of our adventure.'

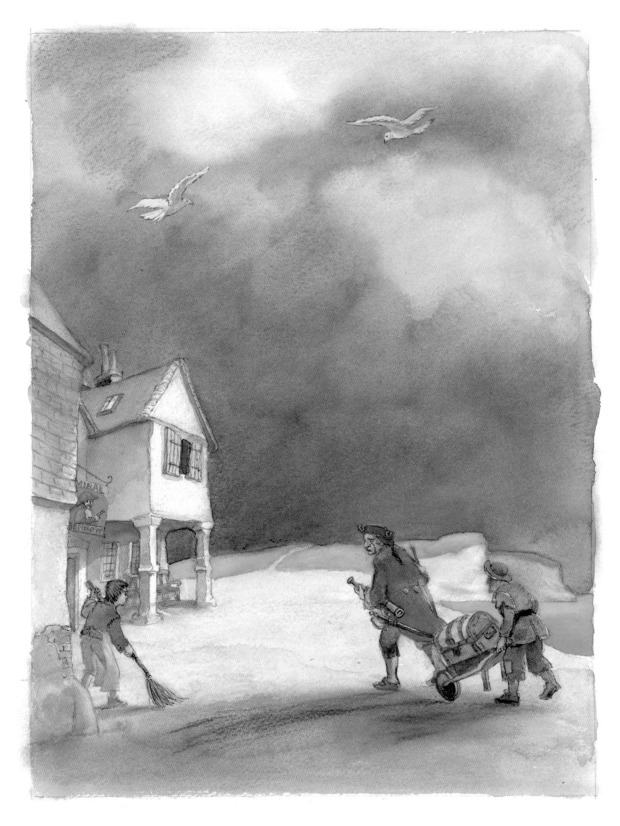

'Fifteen men on the dead man's chest — Yo-ho-ho, and a bottle of rum!
Drink and the devil had done for the rest — Yo-ho-ho, and a bottle of rum!'

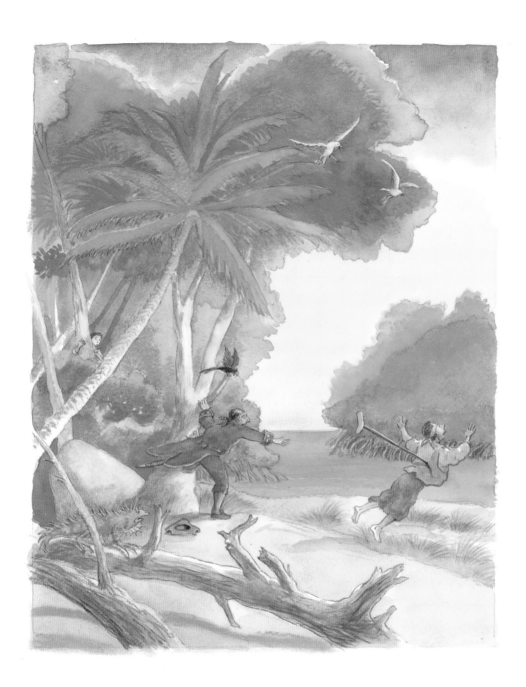

'John seized the branch of a tree, whipped the crutch out of his armpit and sent that uncouth missile hurtling through the air.'

'Treasure Island' — for a young boy perhaps the two most exciting words in literature. By the time I illustrated the story I had experienced the colour and romance of tropical islands. I decided to show Cornwall under grey skies to contrast with the promise of more exotic places.

Alice's Adventures in Wonderland is perhaps the pinnacle of that range of books which loom large as a series of challenges in the career of an illustrator: the attempt is probably best made while the illustrator is young and reckless, but each time I limbered up to make the assault one of my contemporaries announced they had already started and I waited for another window of opportunity. Ralph Steadman, Justin Todd, Anthony Browne and Helen Oxenbury have all produced fine and quite different versions. This is what makes 'Alice' such a challenge. There are many classic and contemporary versions, and many routes to follow.

I decided to start from the basics, with the real Alice. Alice Liddell, as photographed by Charles Lutwidge Dodgson (Lewis Carroll) always seemed to me to have a rather mischievous little face and looked ready to break out of the Victorian photograph and run free. She is looking beyond the camera, beyond Dodgson the photographer, into her future and at you and me. She seems as much a child of the 1960s or the twenty-first century as the 1860s.

My Alice wears the simple pale striped dress, white stockings and brown button boots she wears in several of Dodgson's photographs. Her hair is dark and simply cut but longer than in the 'Beggar-maid' photograph for dramatic potential (movement, falling, etc.) but not as long as in some other photographs or in Tenniel's version. I wanted Alice to step from the sepia photographic world of Charles Lutwidge Dodgson into the brilliant wonderland of Lewis Carroll's imagination.

OPPOSITE AND FOLLOWING PAGES: *Illustrations from* Alice in Wonderland.

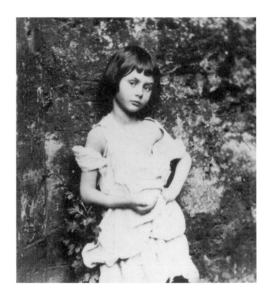

Alice Pleasance Liddell in 'Beggar-maid' outfit, Charles Lutwidge Dodgson, 1858. (Hulton Archive)

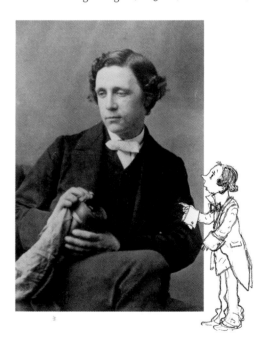

Charles Lutwidge Dodgson, better known as Lewis Carroll (1832–1898), photograph by Oscar Gustav Rejlander, 1863. (Hulton Archive)

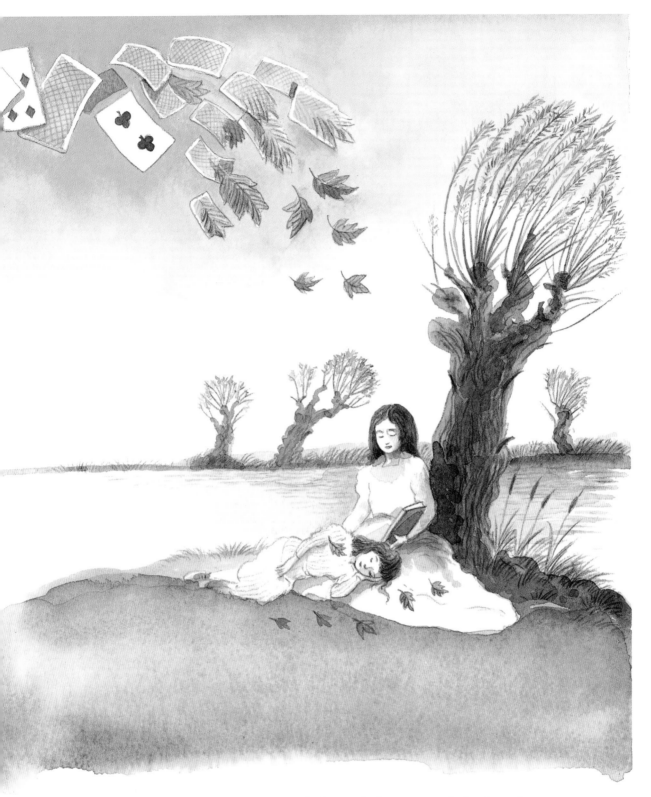

'Alice was beginning to get very tired of sitting by her sister on the bank, and of having nothing to do: once or twice she had peeped into the book her sister was reading, but it had no pictures or conversations in it, "and what is the use of a book," thought Alice, "without pictures or conversations?"'

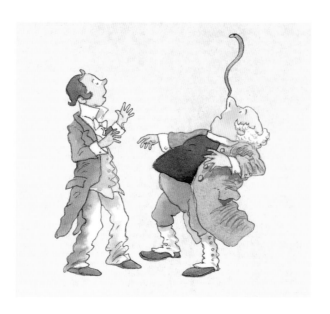

"'You are old,' said the youth, "one would hardly suppose
That your eye was as steady as ever;
Yet you balanced an eel on the end of your nose —
What made you so awfully clever?"

"I have answered three question, and that is enough,"
Said his father; "don't give yourself airs!
Do you think I can listen all day to such stuff?
Be off, or I'll kick you downstairs!"'

I based 'Old Father William' on Alice's father, Henry Liddell, Dean of Christ Church, Oxford, while the 'young man' is based on Lewis Carroll himself.

The story is obviously set near the sea. It takes Alice no time at all to walk with the Queen from the croquet lawn to meet the Gryphon and the mournful Mock Turtle on the shore. I felt the backdrop of sea had been under-used in other versions and, of course, there is nowhere closer to Wonderland than Cornwall.

OPPOSITE: *Alice, the Gryphon and the Mock Turtle sit on the harbour beach at St Ives with Virginia Woolf's 'To the Lighthouse' lighthouse in the far distance.*

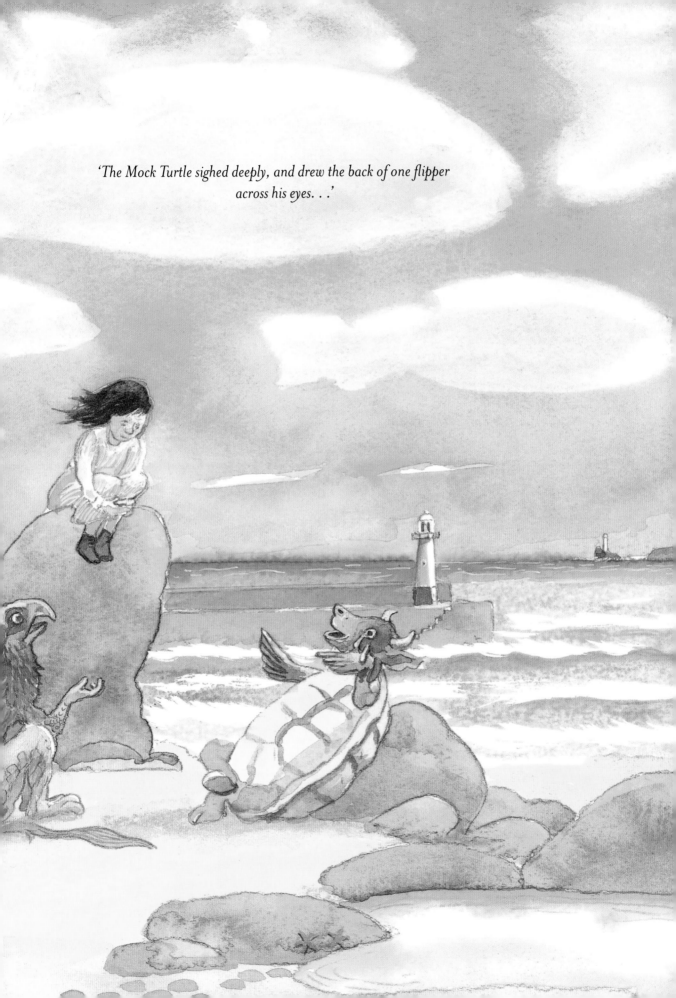

'The Mock Turtle sighed deeply, and drew the back of one flipper
across his eyes. . .'

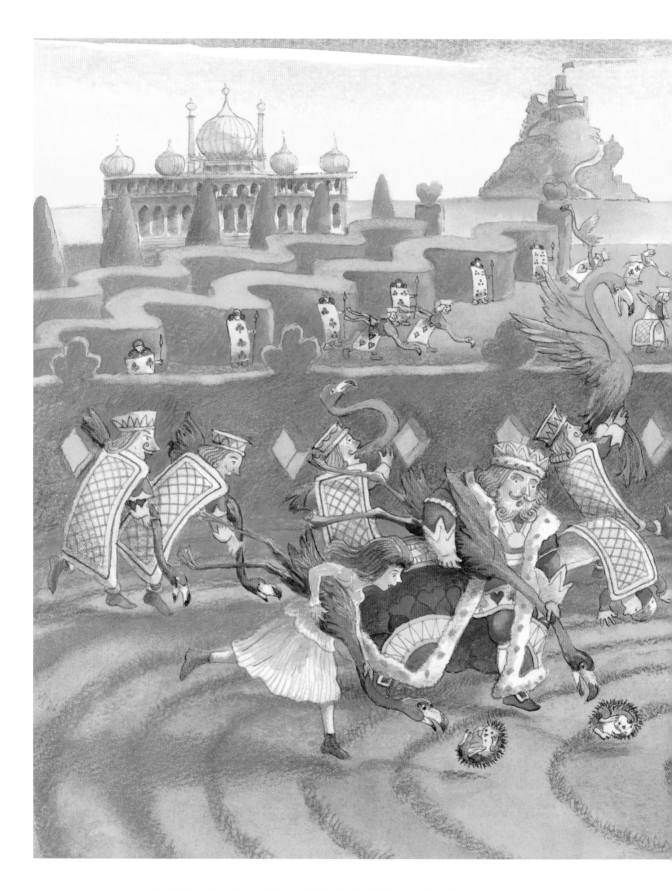

The Brighton Pavilion and Cornwall's St Michael's Mount add to the seaside atmosphere and the 'real', 'unreal' magic of Alice.

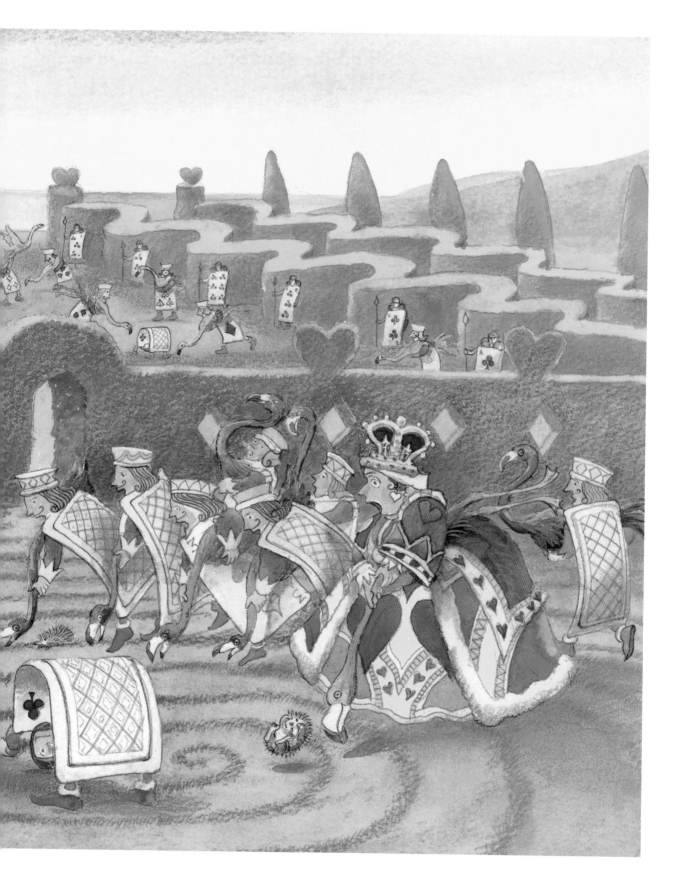

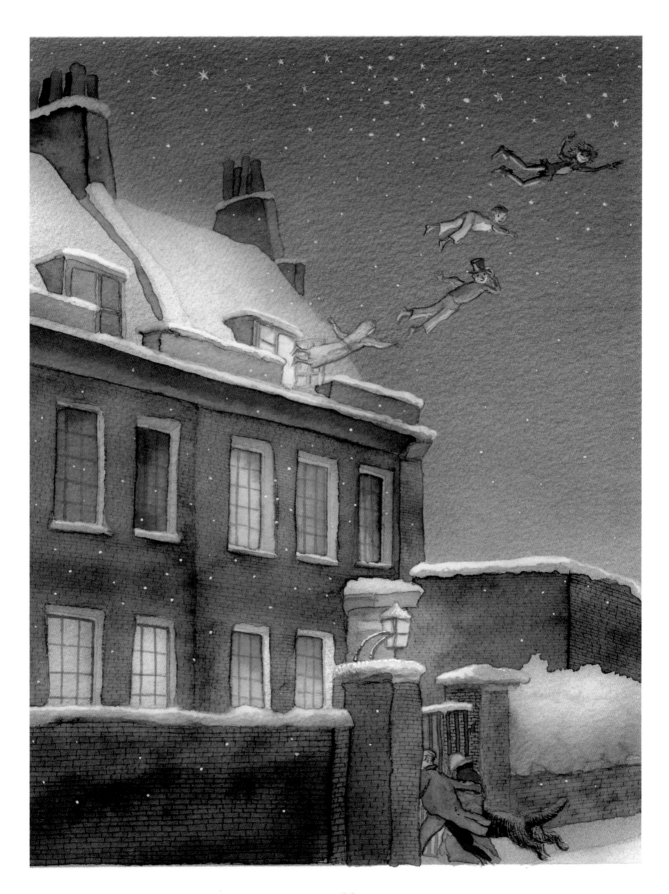

I used our old house by the Thames in Fulham as the home of the
Darling family. Peter Pan and Tinkerbell fly around our son Ben's
room and then lead the children in the flight from the window and
off to Neverland – to the Indians of my childhood games and the
pirates of Pop's Cornish stories. Living in a 300-year-old house
enabled me to set several books there – Dickens, ghost stories and
several picture books.

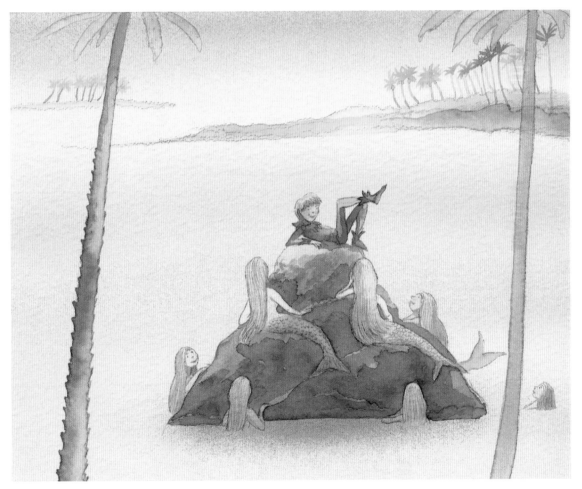

*'The children often spent long summer days on this lagoon, swimming or floating
most of the time, playing the mermaid games . . .'*

THIS PAGE AND OVERLEAF: *Illustrations from* Peter Pan and Wendy.

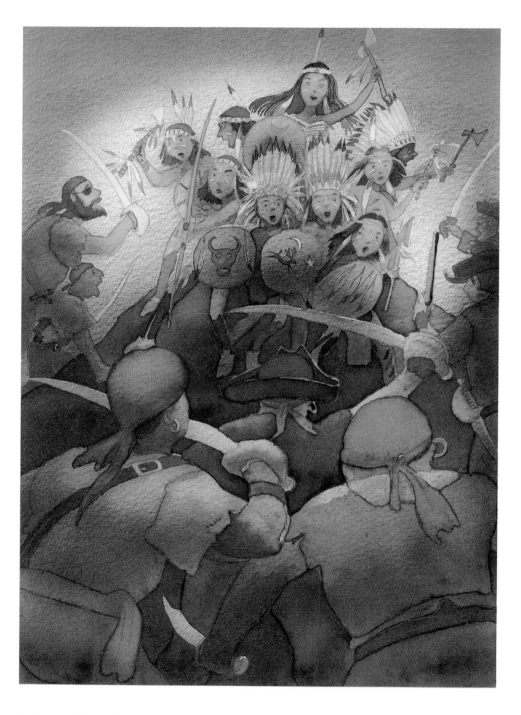

'Thus terrible as the sudden appearance of the pirates must have been to them, they remained stationary for a moment, not a muscle moving; as if the foe had come by invitation. Then, indeed, the tradition gallantly upheld, they seized their weapons, and the air was torn with the war-cry; but it was now too late . . .'

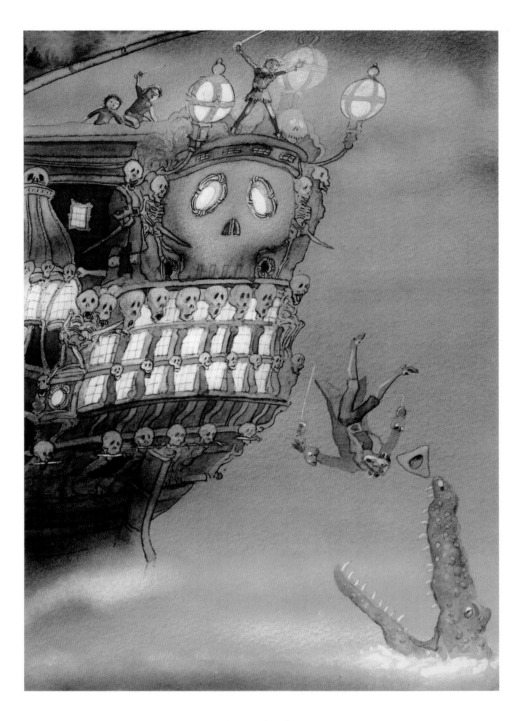

'Avast belay, yo ho, heave to,
A-pirating we go,
And if we're parted by a shot
We're sure to meet below!'

Travels with a Sketchbook

During the 1960s and 1970s I received more and more commissions from US magazines to do reportage drawings, both in the States and Europe. The locations, particularly from *Pegasus* magazine, became more far-flung and remote. How I got there, and what I did on the way back, was up to me. These journeys and sketchbooks have been invaluable in providing inspirations and locations in which to set stories.

I travelled across Siberia by train to make drawings in Japan; I drew oil rigs in the North Sea, oil fields in Arabia and oil pipelines in Alaska. I researched and illustrated books about crafts in Africa and Japan, tracked the migration of reindeer herds in the Arctic Circle and followed in the footsteps of Marco Polo from Venice along the Silk Route to China. My journeys took me from the top of the world in the Himalayas to the bottom of the North Sea.

Classic Fairy Tales and World of Fairy Tales are two of a series of collections of legends and folk tales that I illustrated for Pavilion. The tales are drawn from various cultures around the world – from the South Seas to the Arctic. In each case I tried to set the stories in authentic landscapes based on my sketchbooks.

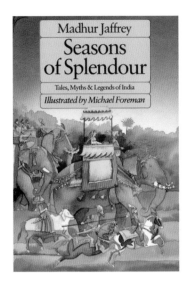

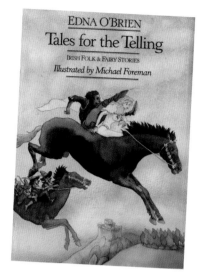

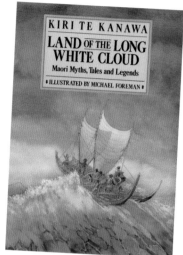

Other collections of tales were inspired by travels through India, Ireland,
New Zealand and North America.

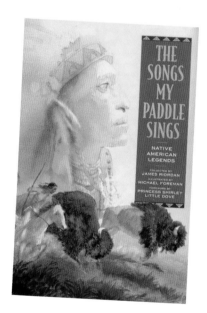

When I'm travelling I try to be invisible – I just want to look and draw.
I also think it is important to walk as much as possible. You see things
at the right speed, and you can leave the roads and follow tracks across
country. Walking with a Queen in Sikkim. Walking in Kerala, India.
The Himalayas, New Zealand, Fiji, Iceland. Rainforests in Siberia to
Lake Baikal. The Redwoods of Canada. The Outback. Bali. Through
Paris and LA with Hockney. Walking with a performing elephant from
village to village in India. I like experiencing these walks alone – maybe
not the whole trip – but days here and there. So it's just you and the
place. Take time. Lose yourself. The place takes over.

On other occasions I have been fortunate to travel with writers. Terry
Jones through France. Alan Garner at Alderley Edge. Leon Garfield
and Charles Causley in Egypt. Madhur Jaffrey in India. Kiri Te
Kanawa in New Zealand. Edna O'Brien in Ireland. Michael Morpurgo
in Sherwood, France and the Isles of Scilly. Sharing and seeing things
through others' eyes. Walking with others' imaginations and following
down paths you would not find alone. Another joy is returning to
places with your children. Experiencing them again through their
eyes, with a new, younger sense of wonder.

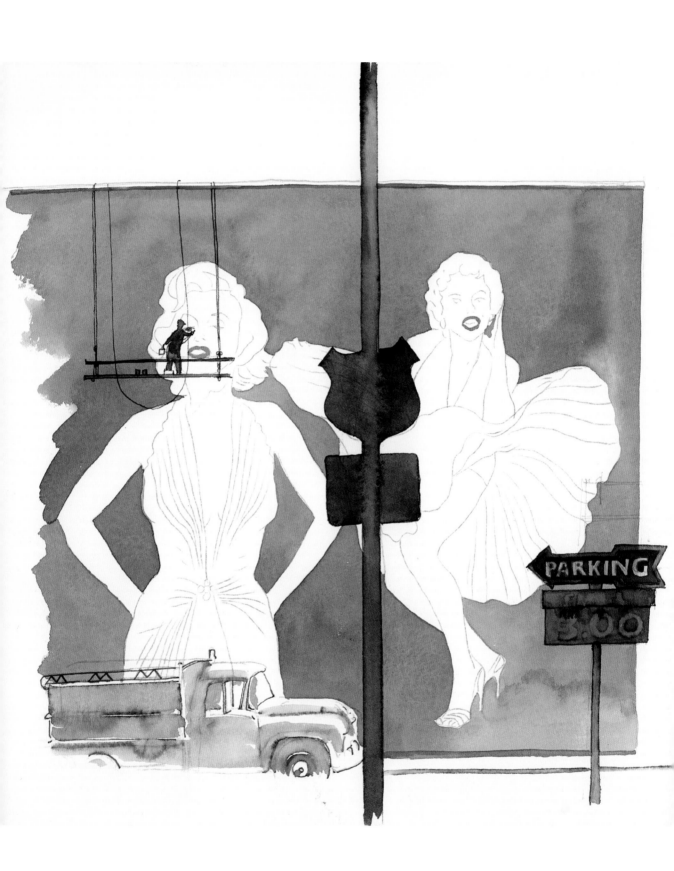

THE LAND OF MY DREAMS

In the Summer of 1963 I left the Royal College with a Travelling Scholarship to the USA.

I bought a Greyhound bus ticket for $99 which gave unlimited travel for 99 days, criss-crossing the country from East coast to West, and from Canada down to Mexico. In this way I got a sense of the vast size and variety of the country, sleeping on the bus to save on hotel bills, and eating and washing at any of the bus stations along the highway. I filled notebooks and sketchbooks. It was heaven on wheels.

But then, particularly in the Southern States, there were still two nations. The Black and the White. The traveller was particularly aware of this on the buses. In the South, blacks were not allowed to sit at the front of the bus. They had to sit at the back. One of the main reasons I went to America was to visit the roots of jazz and the blues. The back of the bus was the place for me.

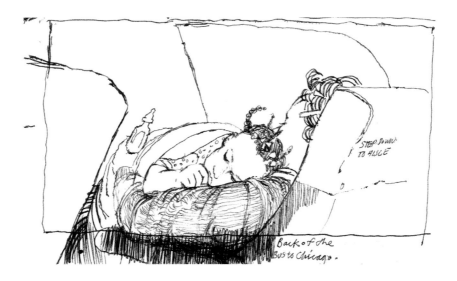

ABOVE: *Mother and child. Back of the bus, Atlanta to Chicago, 1963.*
LEFT: *Giant Marilyn. Hollywood Boulevard, 1963.*

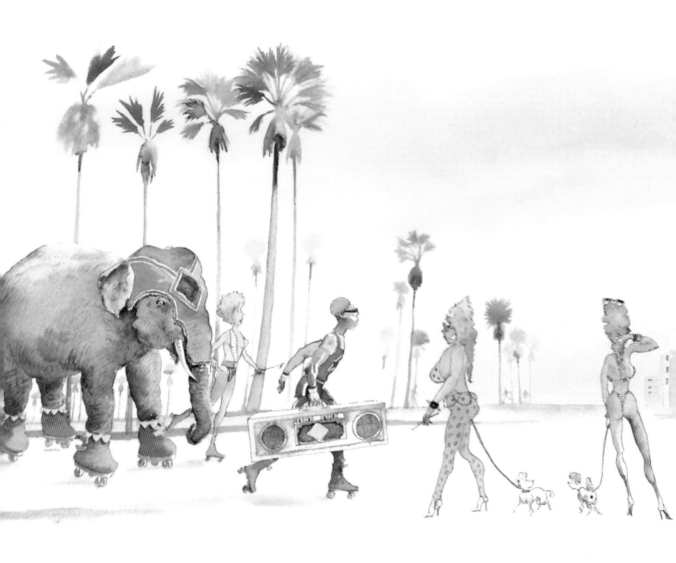

THE PLAYBOY MANSION

Since that first trip in 1963, I have visited the US fifty or sixty times. I have drawn all over America. Oil pipelines in Alaska, refineries in Texas and the Mid-West, the Indy 500 car race in Indianapolis. American football, baseball and Venice Beach, California, where everyone seemed to be on roller skates, including an elephant. Many commissions were set in New York (like drawing Fifth Avenue from Washington Square straight through Harlem) for the *New York Post*.

I only had one 'proper job' during this time. In 1965 I was hired as an Art Director at *Playboy* Magazine. I was encourage to go for the job by Reg Potterton, a fellow Englishman who I met at a party at his house on Fire Island, just along the coast from New York. He was flying to Chicago the next day to start work as an editor at the magazine. 'Come with me,' he said, 'and bring your portfolio. They may give you some illustrations to do.' I didn't expect to be offered a full-time job.

At that time *Playboy* was at the height of its success, selling millions of copies and opening clubs across the States and Europe. It was a period when *Playboy*'s owner, Hugh Heffner, never left his mansion which was less than a mile from the office, by Lake Michigan. All work on the magazine had to be taken to the mansion for his perusal. I liked going there. He was a bit of a 'Brit-o-phile'. He had a classic Bentley which never seemed to leave the garage and an old English sheep dog which, like Hef, never went out. One time the layouts came back from the mansion covered in dog mess.

The 'Bunny Girls', waitresses at the nearby Chicago Playboy Club, all lived at the mansion and sat around the Tudor style fireplace in the Baronial Hall in face packs and curlers. There were suits of armour around the walls and a beautiful Italianate ceiling from which would descend, on Sunday afternoons, a cinemascope screen on which we could watch the latest movies. Usually, the stars of the movies would be among the gathering.

Days. Aug 1975
Venice Beach

The cavernous basement was a catacomb of delights. Games rooms, steam rooms, Jacuzzis and swimming pools linked by fairy grottos lush with plastic palms. It was exciting for about a month. But then I gave a month's notice to quit. I knew that going into an office every day was not for me. So how was it, being a young bloke at *Playboy* in the 60s? Well you must remember, I was born in a sweet shop . . .

In Spring, 1968, I was drawing some of the glamourous houses of Hollywood film stars for the British magazine, *Nova*. Most of the stars no longer lived in the homes they had made famous; in fact many were long dead. The new occupants were the icons of pop music like Sonny and Cher, the Beach Boys and The Mamas and the Papas.

When drawing the 'Homes of the Stars', I stayed in the one-time home of Tyrone Power for a week. One morning I was sitting by the pool when the pool cleaner turned up. 'Excuse me, Mr Power', he said, 'I've come to clean your pool.' The aura of the Hollywood stars lives on, long after they have departed the scene.

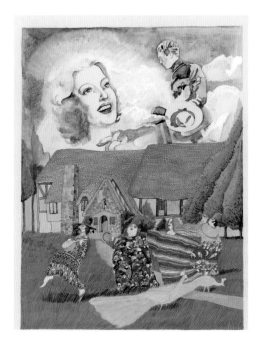

While driving from one amazing home to another, a news alert came over the car radio, 'Martin Luther King has been shot in Memphis. For good news, go to your Chevrolet dealer.' In June of that year, I was in a beach house in Malibu with friends who were going to see Bobby Kennedy speak that night. I couldn't go because I was flying to Chicago that afternoon. By the time I arrived in Chicago, Bobby Kennedy had been shot dead and the National Guard were on the streets.

The Vietnam War was at its height, and so was the protest movement against it. There was a shadow over the optimism of America, but, also, a new youth-led realism – a realism leading to the first black President. An event I never expected in my lifetime.

TOP: *The home of film stars Nelson Eddy and Jeanette McDonald in the 1940s and 50s; and the home of Michelle and John Phillips of the band The Mamas and the Papas in the 1960s. They had been recording all night. 'Michelle is still asleep and John is in the shower,' I was told on my arrival. Later, John played the piano while we had coffee and cookies.*

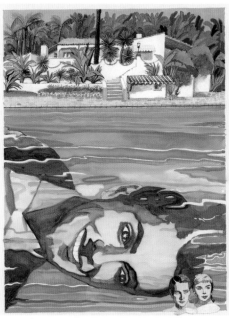

ABOVE: *The home of Tyrone Power. Paul Newman and Joanne Woodward, in the foreground, also lived here for a time.*

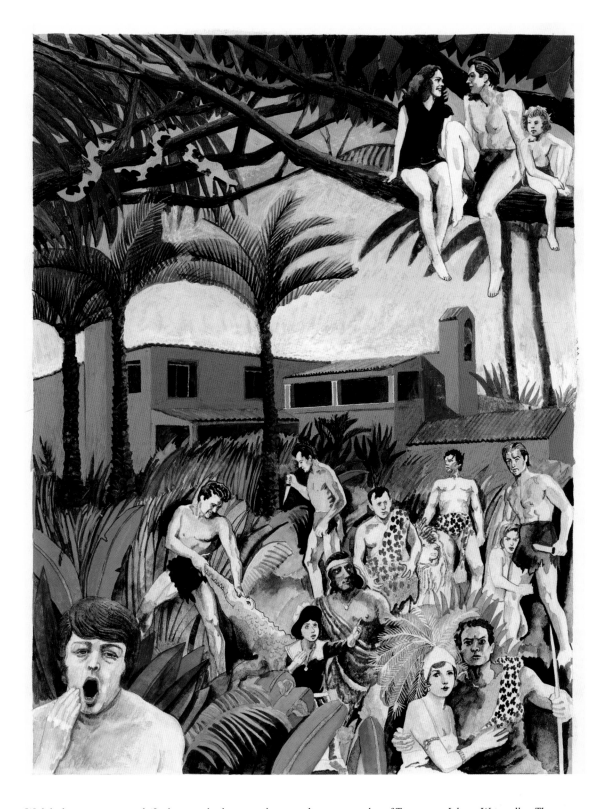

With lush trees it was not difficult to see this luxurious home as the one-time den of Tarzan star Johnny Weismuller. The owner when I visited in the '60s was Brian Wilson of the Beach Boys. He had also been recording all night and couldn't stop yawning.

AMERICA AND CANADA – IN SEARCH OF MYTHS AND LEGENDS

I loved the idea of America long before my first visit in the 1960s, and after many travels there, I love it still. I have only to see a yellow cab in a film and I want to catch a plane. The first glimpse of the mountain range of Manhattan skyscrapers as you cross the East River bridge is thrilling. Then suddenly you are plunged into canyons of criss-crossed streets and the excitement of one of the world's great cities.

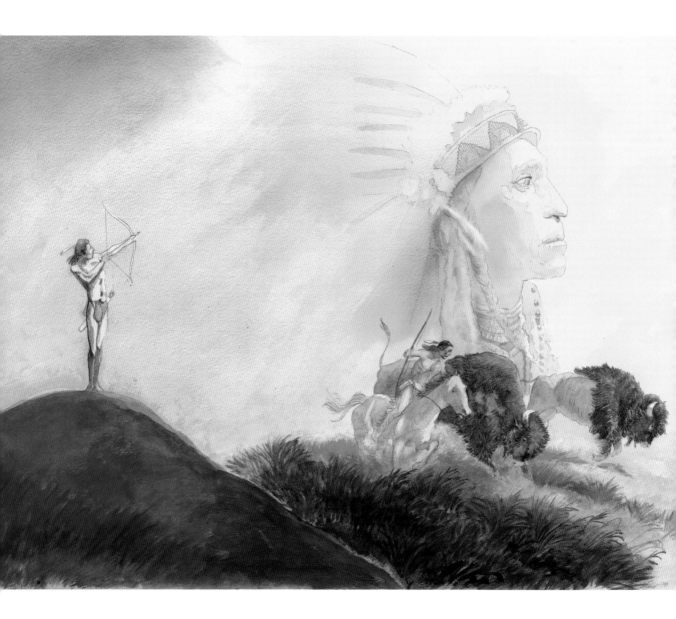

It is truly a land of contrasts. From the hot desert around Palm Springs you can be wafted by cable car to the deep snow in a few minutes. There, you can walk all day through a different country and see no one. Wooden-porched Hillbilly shacks with enormous satellite dishes perch above the log-jammed rushing Oak Creek Canyon in Sedona. My family and I went to sleep in the red magnificence of Monument Valley, and awoke next day to find the Valley white with sudden snow. We visited Nanette Newman and Bryan Forbes in Arizona and while horse-riding and panning for gold, we discussed the books we were to do together. The gold we found was friendship.

Before illustrating *The Songs My Paddle Sings* in 1996, I made many trips through the canyon lands of the South West and the tall forests of the North. I have travelled around the reservations, visiting Indian potters and Hopi craftspeople, learning as much as I could about the culture of the Native Americans. Animals play leading roles in much of the world's treasure of traditional tales. They echo a time when the lives of animals and humans were inextricably bound together. Some North American Indian stories depict an even earlier time, a time when the Americas were inhabited *only* by the animals. Indeed, the animals were credited with the creation of much that was wonderful, and when the Indians arrived each group adopted an image of an animal as its totem, a symbol of unity within the group, and with nature.

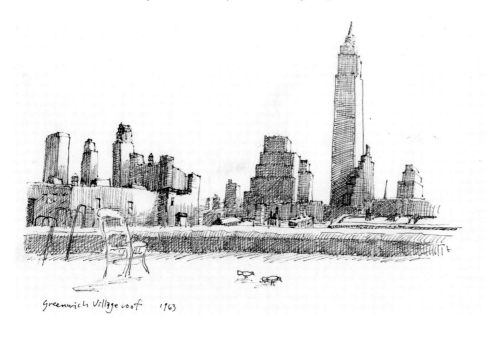

Greenwich Village roof 1963

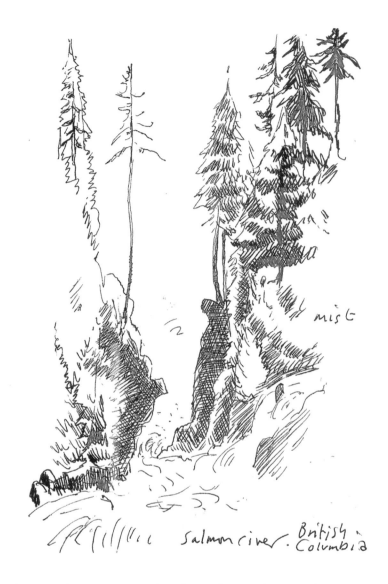

mist

Salmon river. British Columbia

'As the sun lowered in the sky, the peaks caught more colour,
gold and rose. When the sun sank behind the peaks, the
shoulders of the mountains were touched with gold and the
palest mauve. The whole world slowly
turned blue and dark blue and black, except for the
pin prick of stars.'

Salmon River, 1994

RIGHT: *The Thunder Bird beats its huge wings on crag and canyon, based on a Salmon River sketch
(above). Illustration (opposite) from* The Songs My Paddle Sings, *1995.*

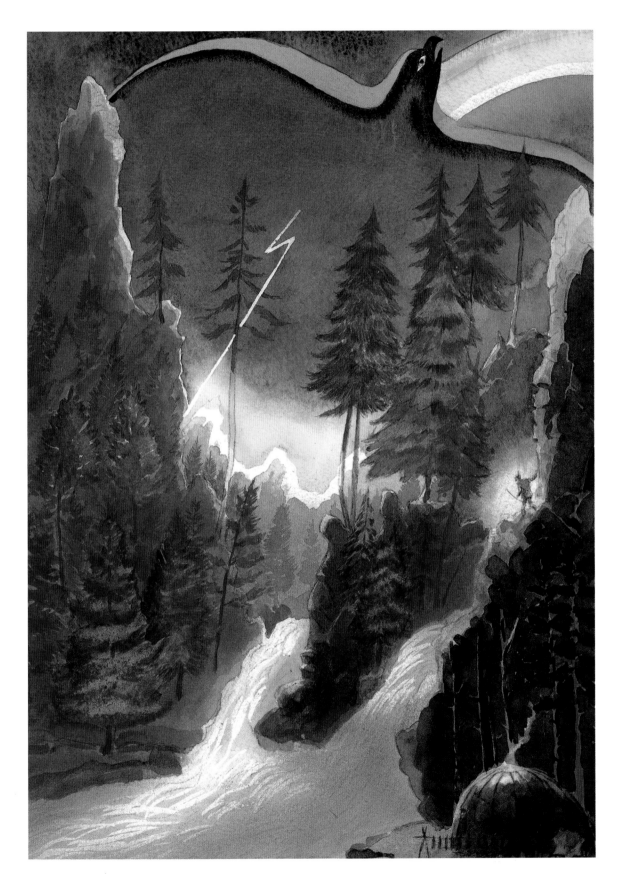

This rocky outcrop in British Columbia became the setting for the coffin scene in 'Snow White'. Illustration below from 'Snow White' in Classic Fairy Tales.

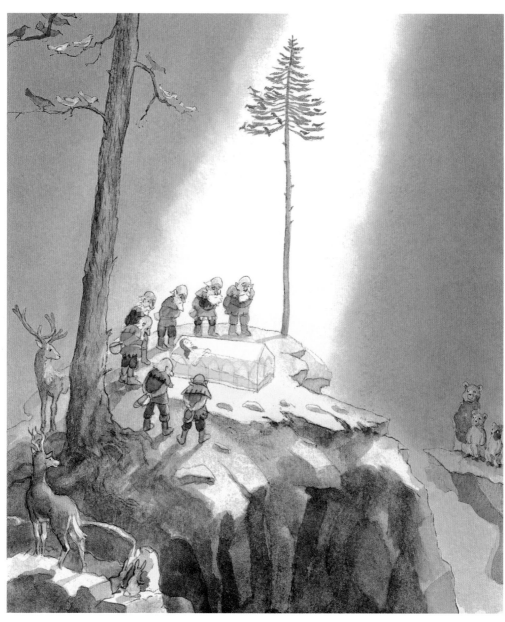

This fallen giant in a Northern Redwoord Forest was the perfect setting for the Native American legend 'The Origin of Stories'. Illustration below from The Songs My Paddles Sings.

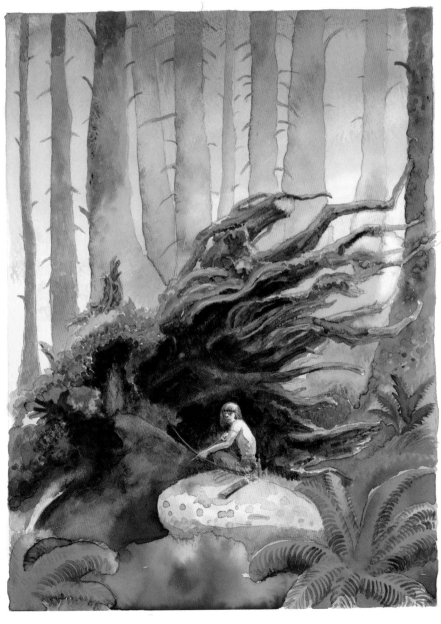

'We drove into Monument Valley along a dirt track. Then we were engulfed by a full-blown red dust storm. Red eyed, we found a tiny motel. Next morning, our young son Ben, opened the curtains and yelled "SNOW!" We didn't believe him – but the red of the day before was now a white world.'

March 1993

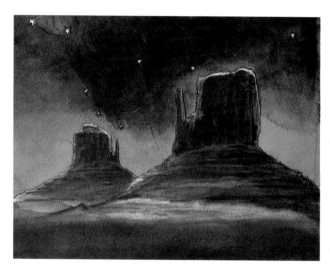 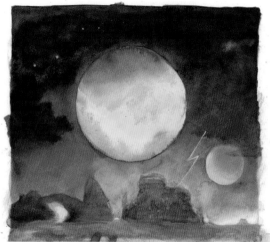

The dramatic colours of Monument Valley change in the moonlight into the long-remembered silhouettes of Saturday morning black-and-white Westerns.

RIGHT: *Image from 'The Creation of the World' in* The Songs My Paddle Sings. *'The New World' is an ancient land where dinosaur tracks can be found on a windblown plateau in Arizona. The precious prints are looked after by a few young Navajo armed with yellow plastic brooms to keep the sand away.*

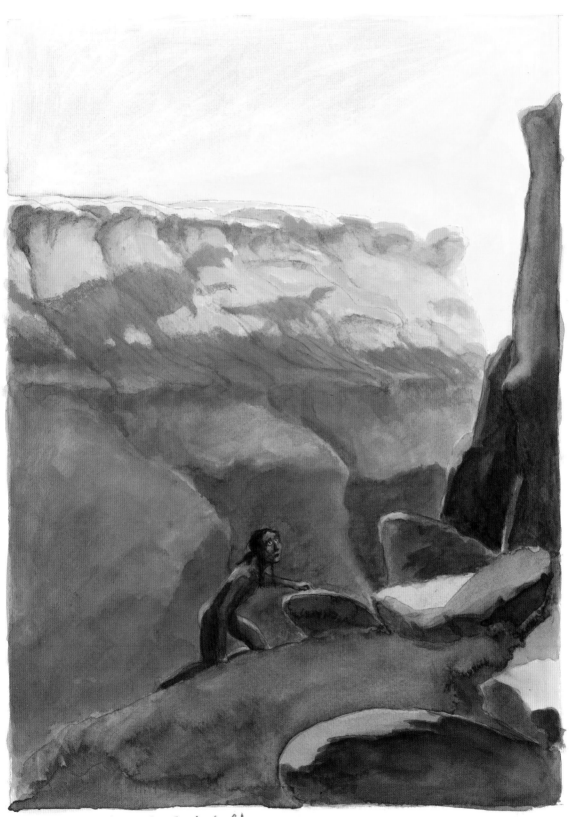

The Creation of The World.

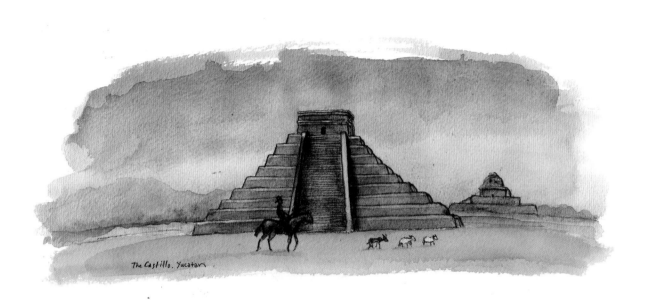

The Castillo, Yucatan

MEXICO AND THE YUCATAN

I first travelled to Mexico driving down Highway 1 from San
Francisco, a wonderful road trip, getting there slowly . . . anticipating
. . . living the dream. Later visits have made me love Mexico even
more. Not just the spectacular temples, but the people, particularly in
the villages. They are so warm and welcoming – and there is no better
place to watch football on the TV than outside a Yucatan roadside bar.

When the Spanish conquistadors arrived in the 'New World' they
found a spectacular old world. The Aztec capital (Tenochtitlan) was
built on islands in a vast lake. It was destroyed by the Spanish and
the beginnings of Mexico City were built amid the ruins. Today it
is necessary to travel to remote areas of Mexico and the wonderful
Yucatan peninsula to see something of the scale and splendour
that Tenochtitlan must have had. But Popocatepetl, the Smoking
Mountain, broods over modern Mexico City, and reminds the
citizens of a rich and violent past.

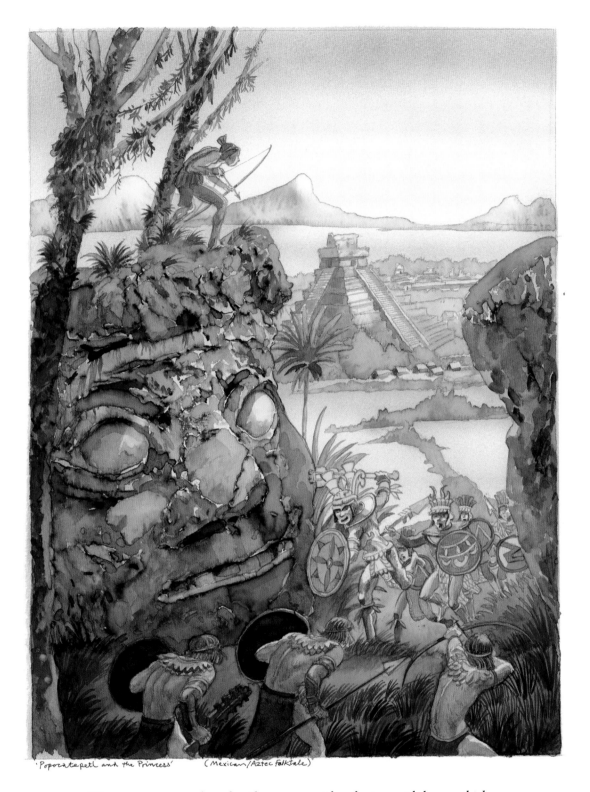

'Popocatepetl and the Princess' (Mexican/Aztec Folktale)

'The snows came and, and as the years went by, the pyramids became high,
white-capped mountains.'

From 'Popocatepetl and the Princess' in World of Fairy Tales.

In 1966, I was asked by the BBC to write and design six short animated films. Jannik Hastrup, a Danish animator, was already at work on a film of *The General*. It was agreed that Jannik would make all the films in Denmark where the production costs were lower. He lived and worked in an old farmhouse north of Copenhagen.

Jannik, his wife and two children, were joined by animators from Poland and Czechoslovakia, as well as Denmark, and most of them brought their children. Everyone worked on the films, including the children, tracing and painting. I made frequent visits during the following two years, often in the snows of winter; but the long summer evenings are what I remember best.

Andersen was born in Odense, Denmark, in 1805. His stories brought him great fame and his house in Odense is now the Hans Christian Andersen Museum.

The orchard at the back of the farmhouse was completely overgrown. The forest of fruit trees, apple, pear, plum, entwined their branches overhead like a green cathedral. Below, blackberries, gooseberries, red and blackcurrants, formed tunnels through which the children crawled when we played 'hide and seek'. You could hide in the branches of an apple tree and eat pears and plums from neighbouring trees. Sitting high amongst the fruit, hearing the children laughing below, I felt as though I was in the garden of dreams.

Perhaps this is the kind of place where dreams, the bits of dream which are never finished, end up. Tangled in brambles in a garden of dreams. When you wake up before the end of a dream, you can never get back to it. It is lost. But where? Maybe, in an old orchard in Denmark? I tried to write a story about it, but it just didn't work. There was not enough logic to it. Without a sense of its own logic, a story is just an idea. It remained just a page in a notebook. Until 1972, when I went to the Himalayas – and found the missing ingredient. There, in this land in the clouds, dreams could be blown from the World below and lay lost in drifts of snow . . . waiting to be discovered. On my return from Sikkim I wrote and illustrated *Land of Dreams* about an old man and a boy who rescued dreams.

The story of 'Inchelina' which I illustrated for *Classic Fairy Tales* has many of the classic ingredients. A closely observed and recognisable world, the tiny child, a series of close encounters opening out into the best ingredient of all – a fabulous journey. At the end, the swallow tweets the story to the man who tells fairytales. The man, of course, is Hans Christian Andersen.

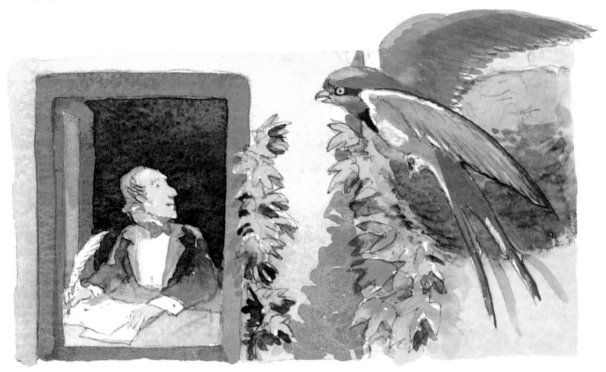

"'Farewell, farewell," called the swallow, with a heavy heart, and flew away again, far away back to the North. There he has a nest above the window of a man who tells fairy tales. "Tweet, tweet," sang the swallow. And the man heard it and wrote down the whole story.'

ABOVE: *From 'Inchelina', by Hans Christian Andersen, retold by Erik Haugaard in* Classic Fairy Tales.

Red Riding Hood . World of Fairy Tales

'Once upon a time, by the edge of a deep, dark wood, there lived a little girl.'

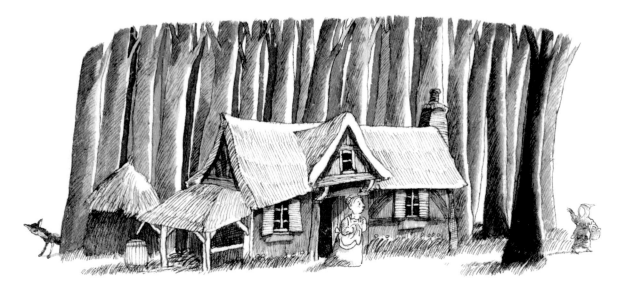

THE FORESTS OF EUROPE

From the very early days of drawing the old trees over and over at the
Saturday morning art class, I sensed the stories held in their branches
and twisted trunks. Time – the passing seasons, snow to blossom to
fruitfulness. Ancient forests have even longer, deeper, sometimes
darker tales to tell and, across the world, have been a rich source of
folk tale and legend. When Jacob and Wilhelm Grimm and Charles
Perrault began collecting stories the great forests were still very much
part of the real world. The stories they heard grew from the folklore of
the forest. Such stories, distilled by generations of re-telling, convey
the deepest wishes and fears of the ordinary people. They tell of the
past that is inside us. The past which is outside is History. The past
inside lives.

When illustrating 'Little Red Hiding Hood' for a collection of classic
tales by Angela Carter, I tried to convey the lurking danger of the
shadowy wolf amongst the trees, and Red Riding Hood like a drop
of blood from his jaws.

LEFT: *From Angela Carter's* Sleeping Beauty and Other Favourite Fairy Tales.

RUSSIA TO JAPAN ON THE TRANS-SIBERIAN RAILWAY

In 1970 I was asked to do drawings at the World Fair in Osaka, Japan. I decided to travel there by train across Siberia and spend my fee returning home around the world by plane and boat via Australia, Fiji, Tahiti, Hawaii and back across the USA. I bought a chocolate safari suit from 'Take 6' in Soho and a sheath knife from the Boy Scout shop in Buckingham Palace Road. I was ready for the world. This was at the height of the Cold War but I got permission to travel across the Berlin Wall and on through East Germany and Poland to Moscow. I spent three days in Moscow. Tree-lined, litter free, with beautiful churches, quiet backstreets and little traffic. St Basil's Cathedral was more fantastic than any fairytale castle. Then, it was all aboard the Trans-Siberian Express. The Sea of Japan was three weeks away . . .

I took books to read on the journey but they remained unopened in my bag. I was glued to the train window. The forest went on for days, dotted with wooden villages with small churches and hay ricks. The track was fringed by an endless ribbon of lupins. On a green hillside girls with flowers in their hair were garlanding cows. Suddenly the forest stopped, and there were days and nights of rolling steppes and lakes like fallen bits of sky. Russian folk songs serenaded us from the dining car. The Russian folk tales grow straight out of those dark forests and the endless steppes. The rivers run with spirits and the deep cold lakes make you shiver with anticipation.

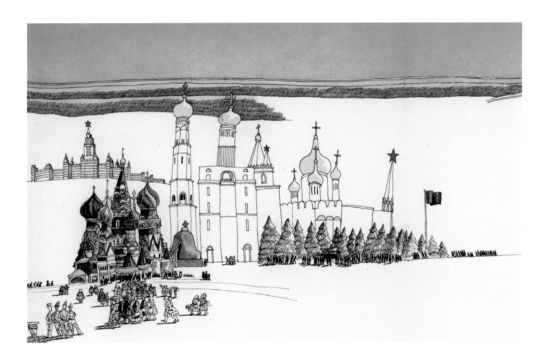

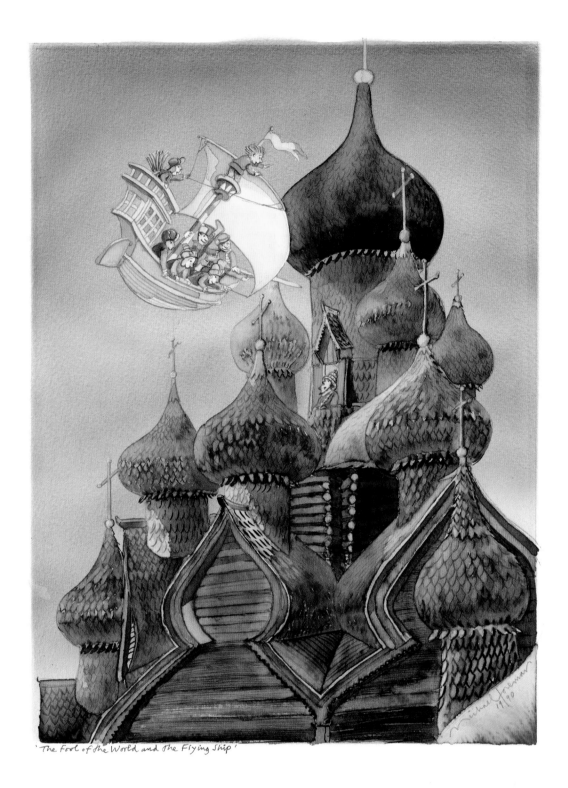

'The Fool of the World and the Flying Ship'

'Just then the Tzar was eating his dinner. He heard their loud singing, and looked out of the window and saw the ship come sailing down into his courtyard.'

ABOVE: From 'The Fool of the World and the Flying Ship' in World of Fairy Tales.
LEFT: From my Siberian Sketchbook.

LIVING TREASURES

From the Siberian port of Khabarovsk I went by boat to Japan. The
World Fair did not detain me long and soon I was off on the amazing
bullet train to explore Japan. I made several more visits during the
next thirty years. On one trip, I worked on a book describing the
working methods of the most famous artists and craftspeople of the
day. They had the good sense to live in beautiful, remote areas on the
Japanese islands, far from the polluted sprawl of the industrial cities.

These 'living treasures' continued to work in the ancient ways of
pottery, weaving, sword making, paper making and lacquer work.
I was privileged to see this old side of Japan, and the experience was
invaluable when I later had an opportunity to illustrate a collection
of traditional Japanese stories.

ABOVE: *From the Japanese folktale 'My Lord Bag-O'-Rice', in* World of Fairy Tales.
OPPOSITE: *From 'The Shining Princess' by Eric Quayle. The red stamp in the corner of the picture is my name.*

'In Old Japan, in the far-off days when dragons roamed the land, there lived a brave young warrior named Fujiwara-san who was never happier than when he was waging war against the Emperor's enemies.'

More recently I returned to paint thirty-six views of Mount Fuji, following in the footsteps of my hero Hokusai, who made thirty-six views one hundred years before. The mountain still managed to appear 'sublime and divine' above the industrial plain. The link which legend makes to the time when man lived closer to nature seems particularly poignant in a crowded country like Japan. Physical links are miniaturised, a stone for a mountain, a bonsai for a tree. But the stories remain epic.

In 1972 I was invited by the Queen of Sikkim to visit her country high in the Himalayas to help with a collection of traditional Sikkimese tales. The Queen was American-born Hope Cooke, who had met the Crown Prince of Sikkim in Darjeeling while she was still a student. Four years later, in 1963, they married. The old King died and the American college girl became Queen.

When Hope found that the traditional tales had never been written down, she began a programme to collect and record them and I was asked to help with the project. It required travelling across high, snowy passes by jeep, mule and yak with guides and an interpreter to hear the stories from storytellers.

The small country above the clouds had a big effect on me. The royal palace, elaborately painted but with a tin roof, stood with a small Buddhist monastery on a high plateau, ringed all around with Tibetan prayer flags. On my first morning I was up early to see the sun peer over the Eastern peaks and turn the snow pink on Mount Kanchenjunga.

The monks were laying their washing out on the grass and whirling their prayer wheels. An old monk came out of a side chapel carrying a couple of empty dishes and a half empty bottle of Tizer, the remains of the breakfast of Kente Rompoche, the reincarnation of a very holy Lama, who lives and studies there. He sat on the highest pile of cushions to show he outranked everyone. He was seven years old.

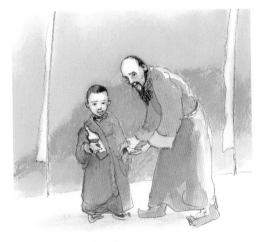

Jamyang Khentse Wangpo Rinpoche
the reincarnation of a high Lama,
with a bottle of orange Tizer.
The Royal Palace plateau . Gangtok, Sikkim

An ocean of cloud blanked out the surrounding valleys, and the plateau became an island with its own sun, King and Queen, and a High Lama who drank Tizer.

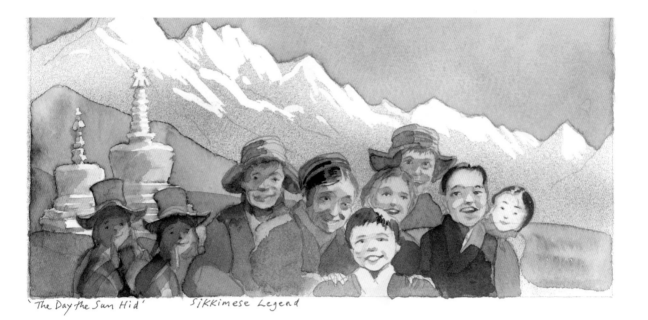

'The Day the Sun Hid' Sikkimese Legend

Sikkim really was like the mythical land of Shangri La. A land hiding in the clouds.
A land of deep snow and gushing streams, orchids, legends and gentle people.

WALKING WITH THE QUEEN OF SIKKIM

I have never walked with a Queen before, and it is an odd feeling,
particularly as everyone threw themselves to the ground and repeatedly
bumped their foreheads on the grass until we had passed by. It was,
at the same time, very down to earth. Buddhist monks pottered about
chanting to themselves, twirling their little prayer wheels and stepping
around ducks, chickens and sheep. I stayed in a small bungalow at the
end of the plateau and, at 8pm, the Palace housekeeper turned up with
a crate of beer. 'Drop of what you fancy, dear boy. From the Queen.
She noticed how you knocked it back at lunch. No, I won't join you.
Mustn't get tiddly pie. Bangers do you for breckers?'

I started on the beer. A cloud quietly bumped its way around the house
and the top puff or two rolled over my open windowsill and explored
the room, followed by chanting and the sound of a distant bell. A flash
of lightning and a rumble of thunder completed the spell.

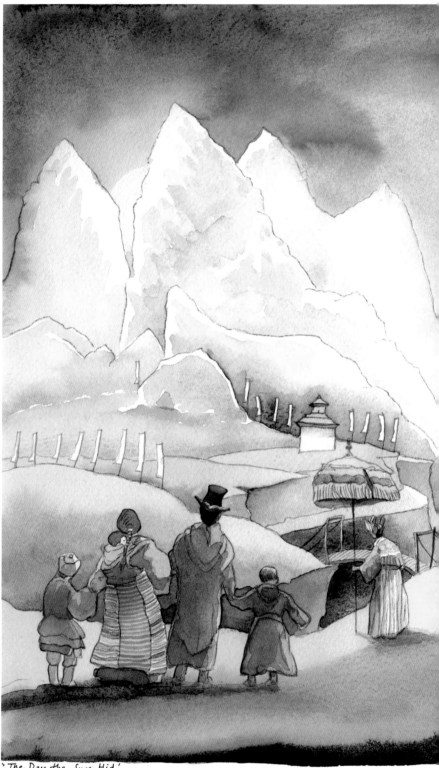

'There was once a beautiful and peaceful country. It was high in the mountains on the roof of the world, and a land of steep deep green valleys and swift flowing rivers. Every day the sun climbed above the snowy peaks and shone upon the land. People said that if trouble ever did come it would last only as long as the shadow of a flying bird.'

From 'The Day the Sun Hid',
in World of Fairy Tales.

'The Day the Sun Hid'

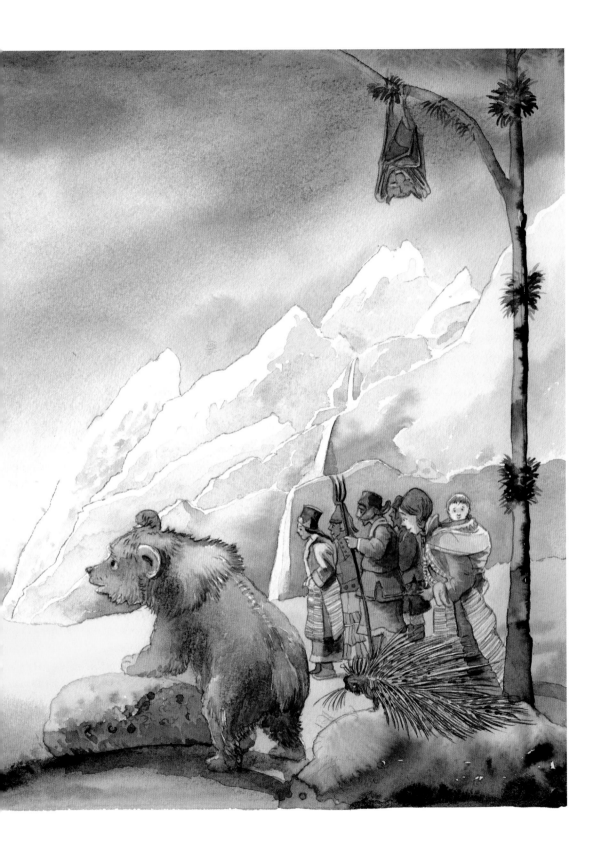

THE MARKET PLACES OF ARABIA AND AFRICA

Travelling through Morocco, Algeria and Libya to the wonders of Egypt and the oil-rich states of Arabia, I found that the marketplace is still at the heart of communities – and, at the heart of most markets, is the storyteller. In the marketplace in Marrakesh, for instance, where there are acrobats and snake charmers, the largest and most attentive crowd surrounds the storyteller. The nearby queue for the open-air dentist hangs on every word. The listeners range from the oldest, hearing the stories for the umpteenth time, to the youngest child possibly hearing them for the first. Here there are no children's stories and adult stories, only good stories. The weak stories were forgotten long ago.

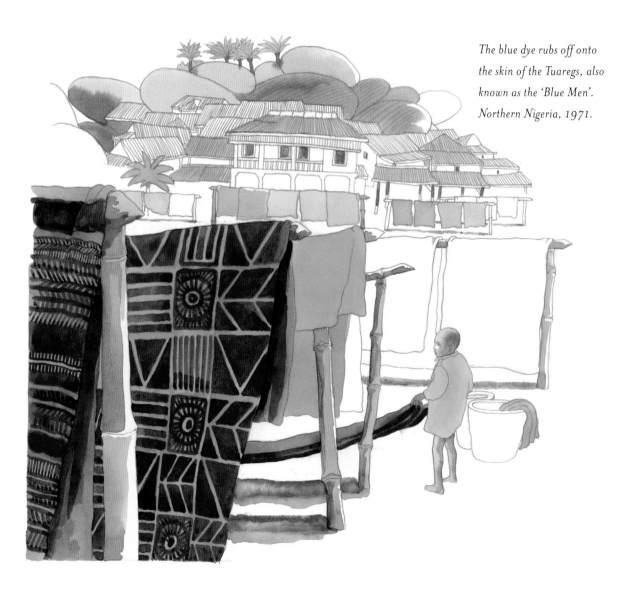

The blue dye rubs off onto the skin of the Tuaregs, also known as the 'Blue Men'. Northern Nigeria, 1971.

While researching a book on the arts of West Africa I visited many towns and villages. Market day was always the most important day of the week, and the market in Kano, a town on the southern fringes of the Sahara, was particularly exciting. Kano is one of the crossroads of Africa, and in addition to all of the local produce and cloth and pottery, there were silver and spices from Arabia, bronzes from Benin, big glass beads and wood carvings from Nigeria and the Cameroon, and intricate beadwork from the south. Smoke from the potters' fires mixed with the camp fires of the Blue Men, the Tuareg, who would shortly re-cross the desert with their camel caravans.

Scene from 'The Boy and the Leopard' in World of Fairy Tales. *This story tells of a market in the far off times when there was a closeness between man and the wild animals. Those days have gone, but the markets continue with all their humour and colour.*

China has a longer legacy of written stories than any other culture: some 3,000 years. Chinese mythology dates from an even more remote past and some of the stories reflect the very creation of the landscape which in turn shapes the lives of the people to this day.

When I travelled around China by train in the early 1970s, Mao was still alive and his portrait and influence were everywhere. Thousands of men and women were working in the flood plains of the rivers, constructing dikes, dams and pumping stations to harness the power and avoid the disastrous floods of the past. In the previous 400 years the Yellow River alone has flooded 1,500 times and changed course six times.

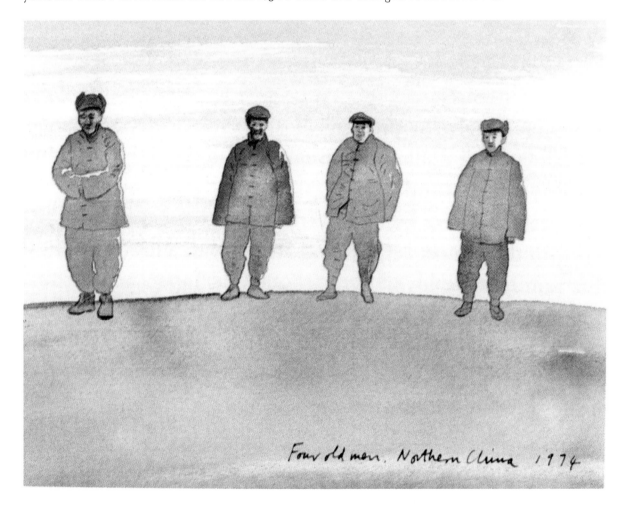

Four old men. Northern China 1974

Four old Revolutionaries – proud and still working.

Scribbles from the train.

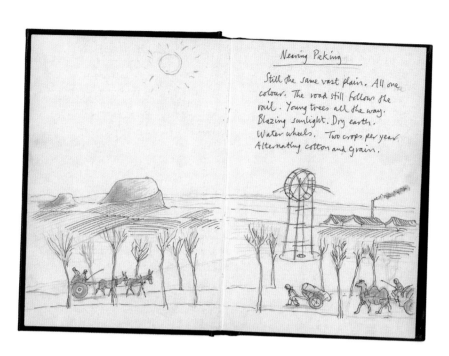

Neaning Peking

Still the same vast plain. All one
colour. The road still follow the
rail. Young trees all the way.
Blazing sunlight. Dry earth.
Water wheels. Two crops per year
Alternating cotton and grain.

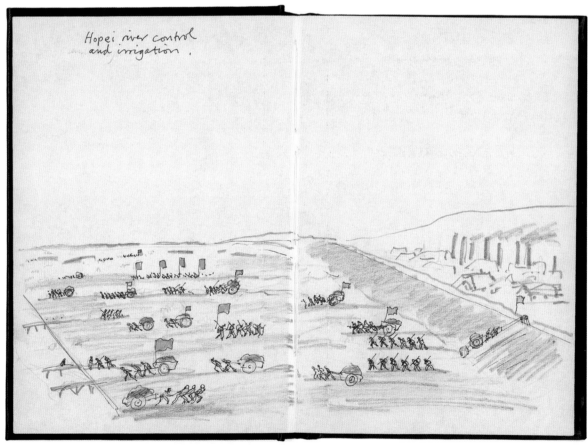

Hopei river control
and irrigation.

Red flags and vast armies of blue clad workers. Patches on work clothes were regarded
as badges of honour – the more patches, the harder and longer you had worked.

'The Mountain God caused four far away mountains to fly through the air and land on the four dragons . . . There the dragons had to remain, weighed down by mountains forever. However they had no regrets and were more determined than ever to help the local people. They turned themselves into rivers, flowing from the mountains across the now fertile land to the sea.'

The awesome yet essential power of the great rivers of China is reflected in the story of 'The Four Dragons' in World of Fairy Tales.

In 1984 I flew to India to research a book of Indian legends retold
by Madhur Jaffrey. Of the teeming millions and millions of Indians,
only four worked in Passport Control and they took their time.
The only movement in the long queues was a fainting girl. After the
usual squabble with taxi touts, I opted for a motorcycle tri-shaw,
like a kamikaze milk float, to take me through the mad traffic to my
hotel. Motor bikes, tri-shaws, cows, bullocks pulling carts packed with
generations of gloriously dressed people, and vendors carrying all
sorts of steaming food, pots and pans, all jostle and clamour through
the narrow streets.

Madhur Jaffrey wafted like a butterfly into the ultra-modern marble
Taj Palace Hotel in Delhi, and whisked me off to the cool mountains
of Kashmir. There, floating among the water lilies and sunsets on
Nagin Lake, we planned the rest of our Indian researches.

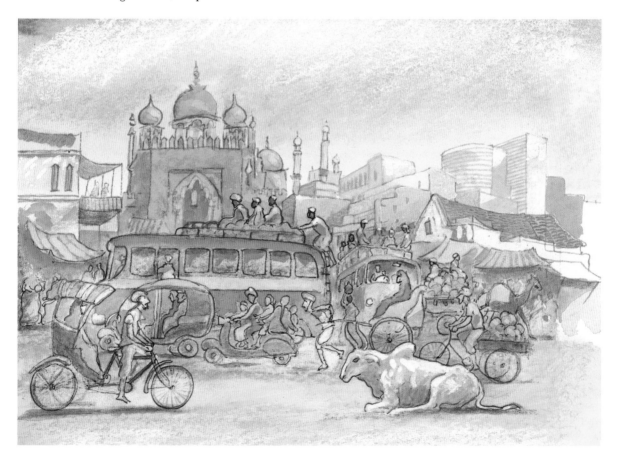

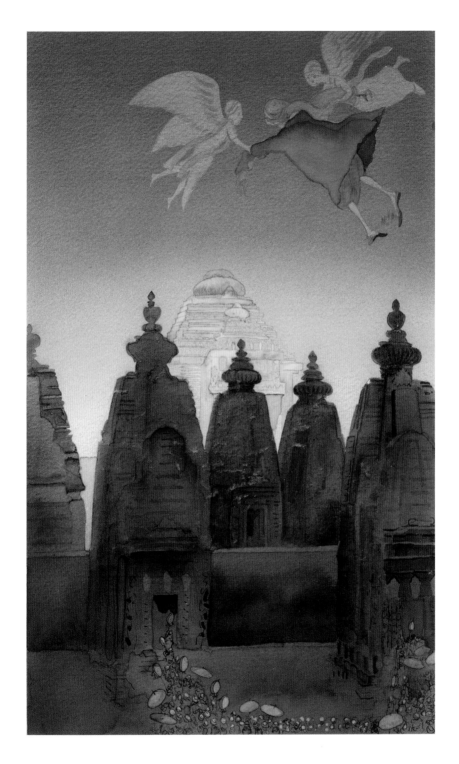

'*Each attendant took one of the old man's hands, lifted him off the ground, and then flew him into the temple's innermost chambers.*'

ABOVE: *From 'The Old Man and the Magic Bowl' retold by Madhur Jaffrey in* World of Fairy Tales *and* Seasons of Splendour.

I travelled the country from top to bottom, and east to west. I have always been stunned by India, and in this trip I saw more than ever before. Deep snow in Kashmir, then through blazing plain and desert to the lush waterways of the South. In Kashmir I climbed with a Ladakh guide way above the snow line to a plateau of absolute whiteness. There was a stone hut and, beyond, deep snow fields running up towards peaks plumed with cloud. Here all was silent except for the odd roll of thunder, and the faintest trickling of water.

'Wed 12th April, 1984. Haryana State. Walking from village to village. The whole flat dusty land was alive with the coming and going of flocks of sheep, goats and buffalo. An elephant and mahout went by. I tag along for a few miles. They travel the countryside entertaining and being fed and sheltered, as do dancing bears who look uncomfortable in their fur coats.'

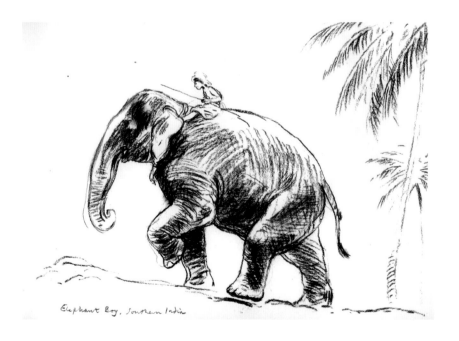

Elephant Boy, Southern India

In childhood games I would sometimes imagine I was the elephant boy.

RIGHT: *Illustration from the story of how Krishna defeated the evil King Kans, in* Seasons of Splendour.

The Arctic is, I think, the most graphic of regions, white as paper, like a vast open sketchbook. I remember one particular journey across the North Cape, 38° below, driving by skidoo into a white haze. No horizon, no colour in the sky, no ground. Just blank white, following an old 'winterway' marked by tall twigs stuck in to the snow some distance apart. Then we saw the reindeer, a vast herd surging like a tide, a brown racing wave breaking over the white hills.

From 'How the Raven Brought the Light to the World' in World of Fairy Tales.

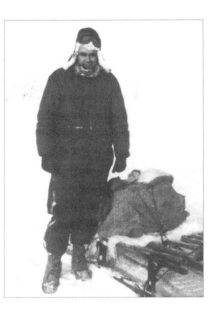

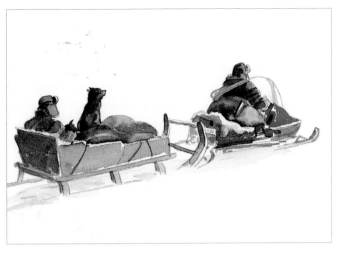

Me and a dog in Lapland, 1985.

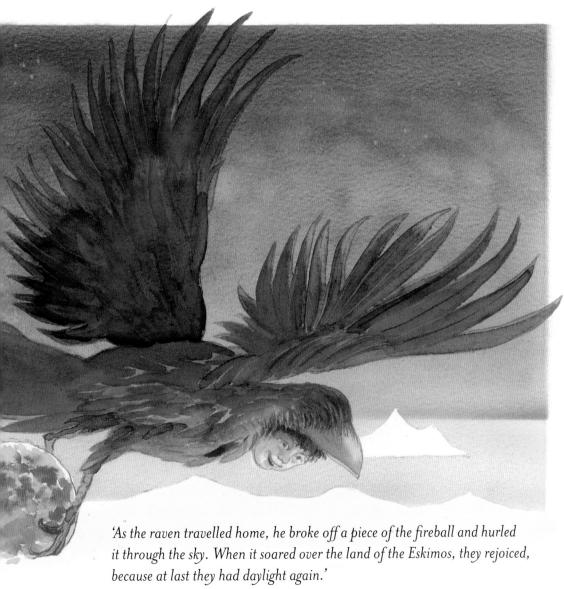

'As the raven travelled home, he broke off a piece of the fireball and hurled
it through the sky. When it soared over the land of the Eskimos, they rejoiced,
because at last they had daylight again.'

IRELAND – HITCH-HIKERS AND GIANTS

In 1985 I went to Ireland to research Edna O'Brien's book of Irish legends, *Tales for the Telling*. Driving along the country roads of Ireland, I frequently picked up hitch-hikers. Not the backpacking variety, but local people on their way to a neighbouring village or market town. Often I would have two or three passengers who had previously never met, yet engaged in the most free-flowing conversation. They must have all kissed the Blarney Stone, for the car became a bubbling billy-can of stories.

Towards the end of one day I picked up an old man in swirling mist. He was standing in the middle of the road, wearing a very tall hat and a belt of string. We travelled on for an hour. The mist had given in to rain when he asked me to stop. We were outside a pub in a small village. We had seen noone for the past hour of our journey. The street was wet, dark and deserted. He offered me money for his ride, and when I refused he dragged me into the bar.

We were engulfed in a multitude. There was a band with marvellous fiddlers, dancing and singing. Salmon and stout for supper. I stayed the night, complimenting myself on my discovery. Before leaving I flipped through the visitors' book. John Wayne, John Huston, Edna O'Brien . . . A land full of characters – each one full of stories.

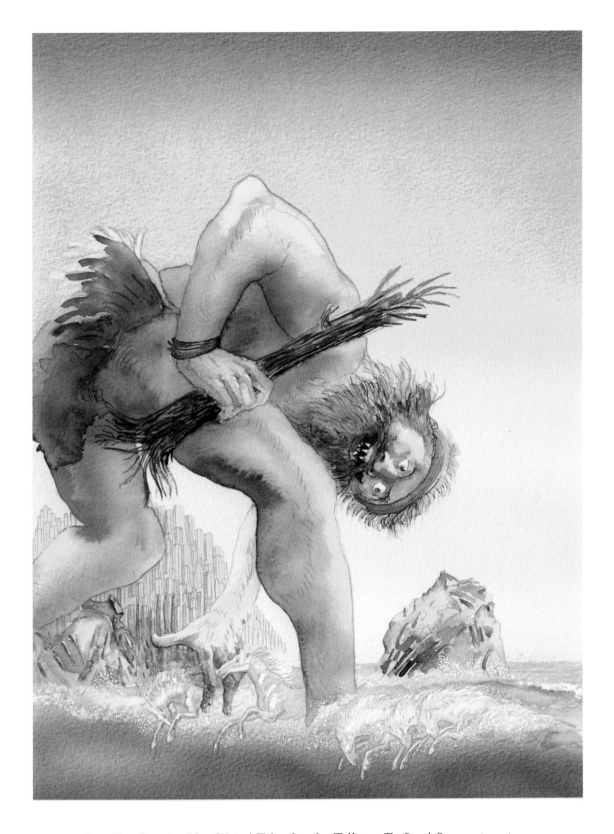

From 'Two Giants' in Edna O'Brien's Tales for the Telling. *The Giant's Causeway is a unique and iconic symbol of the Irish coast. It is the perfect setting for the story.*

Lake Rotorua.
Retracing Hinemoa's swim.
Lake like vast millpond.
Hinemoa's pool. Very lovely, beside Lake,
steaming and inviting. Bath temperature
and about bath depth. Stone shaped like
a seat. It is alive with the Legend.
1987

NEW ZEALAND

In 1987 I went to visit Kiri Te Kanawa in New Zealand to discuss and research a
proposed book of legends based on stories told to her by her grandmother. At the
start of my visit I was fortunate to be present at an enormous gathering of all the Te
Kanawas at their ancestral meeting ground, or *marae*, in Te Kuiti. The celebrations
consisted of three days and nights of feasting, singing and dancing in a wide green
valley. There were hundreds of people, young and old. After the final feast there were
speeches and more singing by the children. Then Kiri sang the traditional Maori song
of farewell. The children and old people joined in at the second verse, and with the
third verse Kiri went up an octave or two and her voice soared above the crowd, the
valley and the green hills. As her voice climbed, the children continued singing, but
their faces were transformed. Their eyes were electric. Kiri's eyes were full of tears.
There was even a rainbow. She can sing rainbows!

We took a flight in a twin engine 'Islander' to Lake Taupo where Kiri used to go
fishing with her father. The Maori legends spring from the dramatic landscape
of forest, river and ocean. Over the next few days we flew to places which were part
of her childhood and coloured the stories she was to write for the book. Rotorua was
the most extraordinary.

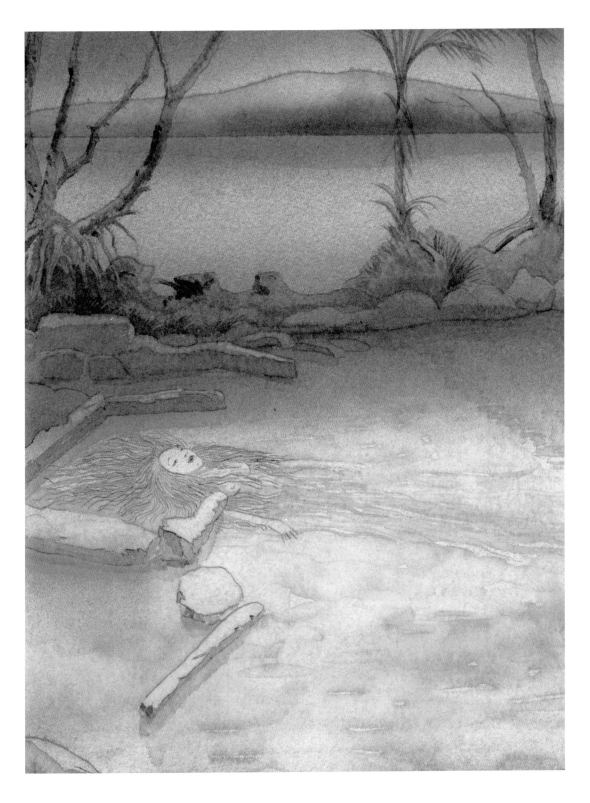

'Hinemoa's Pool' *from* The Land of the Long White Cloud. *No part of the natural setting needed changing – I just added the lovely Hinemoa.*

'The great bubbling pools and geysers and deep steaming chasms of Rotorua are like Hell with a sense of humour. The simmering mud pools seem to delight in their noises and smells and squelches and plops and then a period of serene satisfaction. Nature in need of a nappy. There is also a frightening feeling of walking on a crumbling eggshell which is being boiled from the inside. At any moment, the whole crust of the world could fly off.'

New Zealand, 23 August 1987

OPPOSITE: *Hotu-Puku the beast of Rotorua, who longed to catch the scent of human flesh. From* The Land of the Long White Cloud.

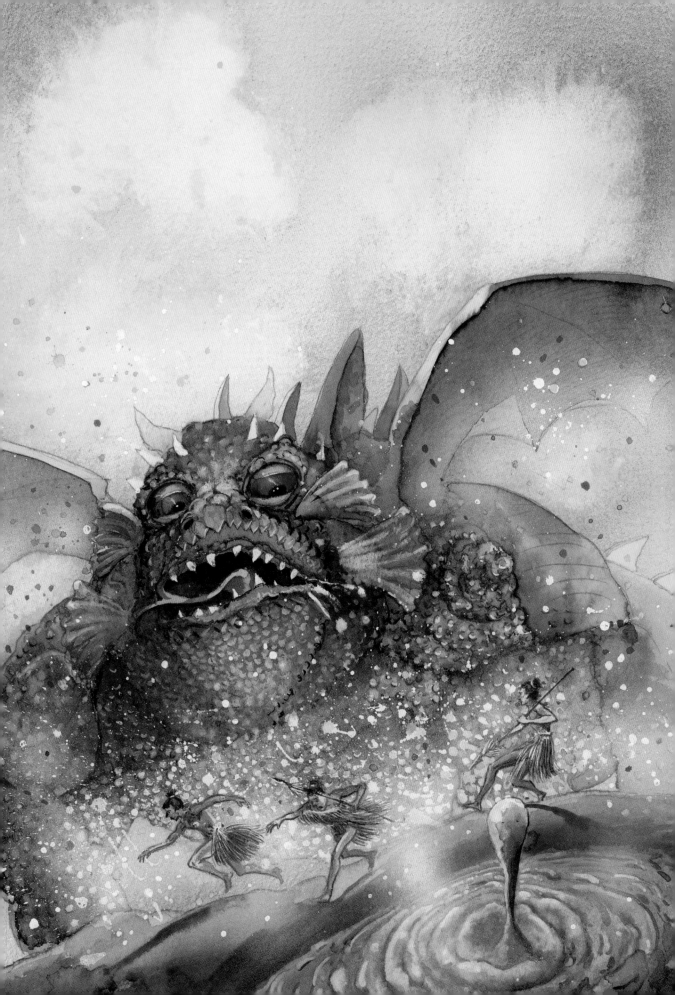

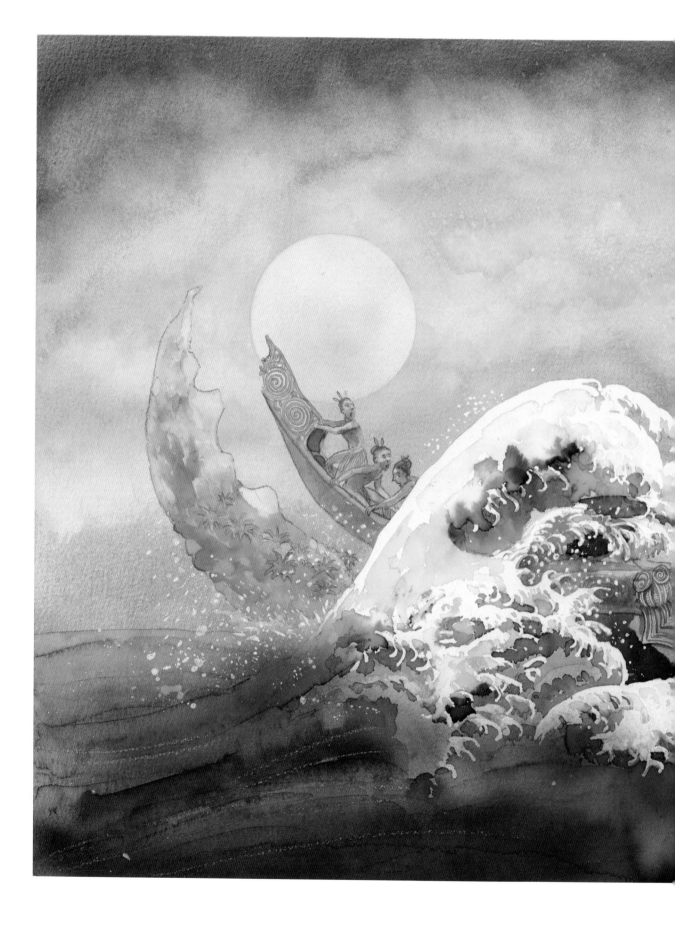

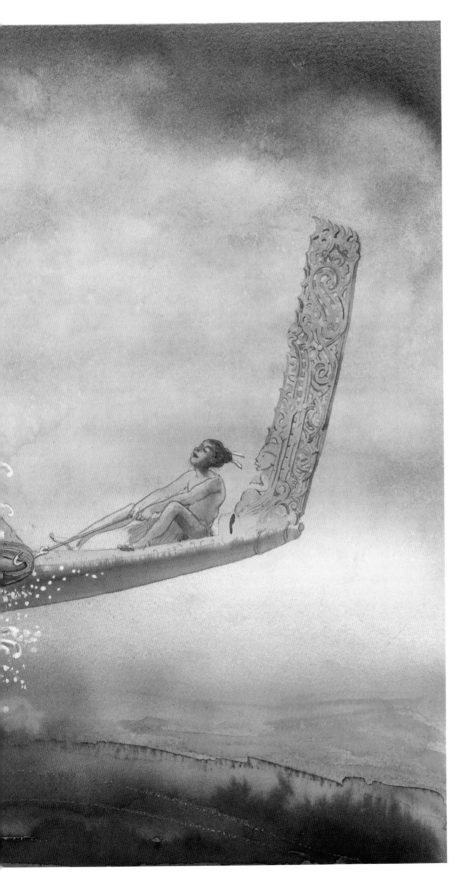

From 'Maui and the Great Fish'
retold by Kiri Te Kanawa in
Land of the Long White
Cloud *and* World of Fairy
Tales. *This story tells how
Maui, the superhero of Maori
legend, caught the great fish of
the South Island of New Zealand.
The Maori name for the North
Island is Te Ika A Maui, meaning
the 'Fish Hook of Maui'. Maui
used the North Island as his fish
hook to catch the South Island,
his Great Fish.*

COMING HOME

I have had a home in St Ives for over 30 years. I have worked and travelled all over the world but nowhere else has the shifting colours and ever-changing moods in such richness as St Ives Bay, and the landscape west of the Hayle river is rich with ancient stories and inspiration for new ones.

St Michael's Mount, rising from the waters of Mounts Bay, topped by a castle, is a spectacular setting for the famous legend of Jack the Giant Killer. The Mount itself is supposed to have been formed by Giant Cormoran himself, tossing rocks into the Bay and piling them up to form his own special island.

We talk of 'second childhood', and as I grow closer to mine, my first childhood pricks my eyes and tingles the back of my neck. You don't need to cross the ocean to find ideas – just look across the kitchen table at your family, or in the attic and the memories of your childhood. Or lay, once more, as you did as a child, with your face in the grass – and dream.

You don't need to travel, here, there and everywhere. But I'm awfully glad that I did.

'The whisper of the low tide in the dark beyond the pier. The two piers' arms outstretched welcoming the oceans of the World, distilling the tales of the World into this tiny bay. The cobbled alley from the quay, up granite steps and in through our gate through banks of montbretia and wild onion and arum lily to our front door. Our door to the World. A sky of stars, a moon sailing on a sea of love.'

St Ives, 2010

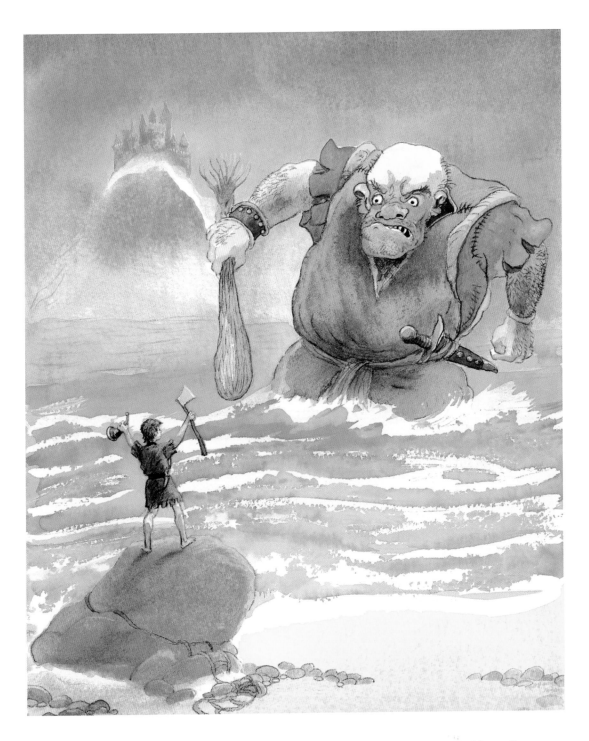

'Long, long, long ago, at the far end of faraway Cornwall lived a giant and his wife. His name was Cormoran . . . He decided to build a great hill of boulders so high that he could see over the forest. He would build a castle on top with windows which he could see through . . . And to make the castle even more secure, he would build his hill and castle some way out to sea.'

From 'Jack the Giant Killer' in Classic Fairy Tales.

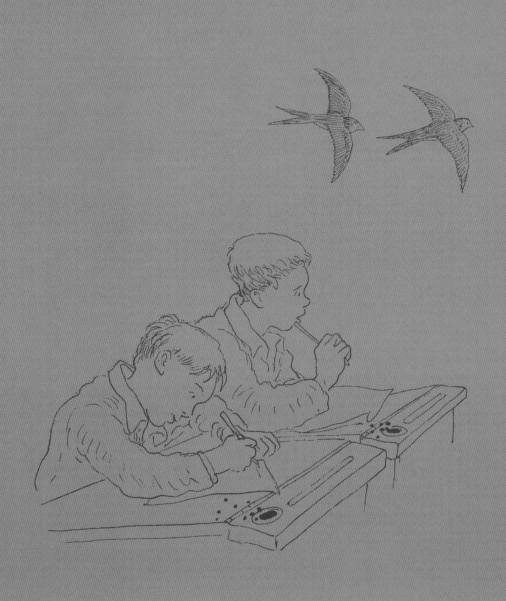

PART III

FRIENDS
AND
COLLABORATORS

Working with Writers

I have been lucky with writers. None have been real trouble. Some I have never met. Some I meet only after the book is finished. Most become friends. The easiest to get along with are the dead ones: Shakespeare, Robert Louis Stevenson, Charles Dickens.

After a childhood largely without books, my life was to become full of writers. Some famous, all different, all generous with their time and experience. Leon Garfield made Shakespeare live for me. Alan Garner revealed the caves and quarries in which his ancestors scraped their livings on Alderley Edge. After walking the dunes of Egypt with Charles Causley, he showed me another side of Cornwall – the gentle fields and lovers' lanes.

I travelled in India with Madhur Jaffrey and New Zealand with Kiri Te Kanawa, gaining unique insights into their stories and the landscapes from which the stories grew. Edna O'Brien gave me a list of 'must-see' places before I set off to illustrate her *Tales for the Telling*. Terry Jones and, of course, the other Michael . . . None of them made me feel like the illiterate that I was.

The closest I came to any confrontation was with Roald Dahl. Many years ago I did an early version of *Charlie and the Chocolate Factory* but Roald didn't like my Willy Wonka. I had drawn a fat Willy Wonka. Growing up, as I did, in a sweet shop, I couldn't resist helping myself to a steady supply of sweets. I knew that if I was the owner of a chocolate factory, like Willy, I would not be able to resist helping myself to more chocolate than was good for me and I would get fat. Hence, my fat Willy Wonka. I had to redraw all the fat Willies. Roald turned to Quentin after that and the rest is history.

RIGHT: *My fat and thin Willy Wonkas.*

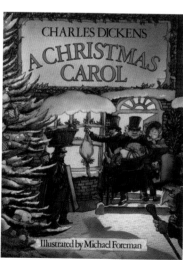

ABOVE RIGHT: *Daphne du Maurier's final collaboration. She signed a limited number of this edition shortly before she died.*

Terry's collections of fantastic stories and fairy tales are a feast of fun and thrills, spooky demons and silly kings, and were a joy to illustrate.

Working with Terry Jones

I first met Terry at the Graphic Studio of my friend, Derek Birdsall. Derek was designing the early Monty Python books and Terry mentioned he was writing bedtime stories for his young children because some of the old classic tales might give them nightmares. Terry and I discussed and researched his *Fairy Tales* and *Fantastic Stories* over a long series of lunches. We had lunches for three years before we found a publisher. With *Erik the Viking* we had to cram the lunches into a shorter period because I had to go to Scandinavia to research the pictures. With *Nicobobinus*, we tried to get smart and set the story in a place where we could get great lunches. Venice. However, as things worked out, neither of us was available at the same moment, so first we did the book – then we did the research and caught up on lunch.

I have illustrated a dozen books for Terry so far, including poems — *The Curse of the Vampire's Socks* — picture books, including *The Sea Tiger* and *The Beast with a Thousand Teeth*, and novels — *The Knight and the Squire* and the sequel *The Lady and the Squire*.

Terry writes cinematically. This makes his books great to read and difficult to illustrate. During the course of a single sentence describing an action his viewing angle can change, zoom in, out, up, down, swing round to the rear and end in a close-up or high helicopter shot. When I show him my single image version of all this, he stares at it like a child staring at a dead pet. Then he usually pulls himself together and finds something kind to say. When all the pictures are finished he is allowed to totally dislike two. These are re-done and everyone is happy, and the publisher takes us to lunch.

Terry's longer tales, like Nicobobinus *and* Erik the Viking *reflect his skill as a film director with his use of dramatic locations and colourful cast of characters.*

TO THE SOUTH OF FRANCE WITH TERRY JONES

It was 6th September 1981. We flew to Paris and hired a car. First stop – Barbizon. When I was a student in Lowestoft, I wrote a thesis about the Barbizon School of Painters. The first group to paint largely out of doors and, therefore, a great influence on the next generation of French artists, the Impressionists. Standing in the long, narrow street of Barbizon, with the famous forest peeping over the rooftops as the evening light turned gold, I fancied I could smell again the oil paints of my old art school, or was it the palette scrapings of the old Barbizon artists laying like truffles beneath the fallen leaves?

We had a beer in a basic bar at one end of the street. It was all chrome and pinballs. There were several interesting small restaurants and we entered the one with the best wine list. Terry put on his 'wine expert' specs and selected a half bottle of this and then a half bottle of that. The bottles were suitably dusty and covered with cobwebs.

We stayed at the sinister Dagger Inn, surrounded by forest, and, in the morning left by the back roads through the forest of Fontainebleau, stopping here and there to search for truffles. Terry snuffled through the leaves like a pig. Then, he leapt to his feet and cried 'Vines. I must see vines!' Soon we were passing chateaux and white cows and vines. We toured some vineyards and bought cases of wine after much tasting.

Next day we made up for lost time on the Autoroute du Soleil, hurtling past fields of dead sunflowers and walled towns on distant hills, until the Mediterranean swam over the horizon. We made a detour to visit Eric Idle, another Python, who lived in the hills behind St Tropez. Eric's hillside had been burnt out in a brush fire the week before and his swimming pool was like rectangle of blue sky in a completely black landscape. We played boules in the ashes and then sat in the pool and had lunch.

RIGHT: *'Out of the Ashes' – lunch in Eric Idle's pool. South of France, 1981.*

Eze village

Later that evening, we arrived at our campsite. The 'best' position had been reserved for our tent. Next to the shower and toilet block. Very convenient, but very noisy and very muddy. We sat outside our tent and drank the complimentary bottle of champagne until most of the population of the North of England passed by on their way to the loo shouting catchphrases from Monty Python and doing 'silly walks'. We left at first light. Four kilometres along the road we found a spectacular old hotel, ringed by palm trees. Below sparkled the Mediterranean. It was cheaper than the campsite. We checked in for a week. Our camping days were over.

We hit the beaches. Gigaro Beach, Club 55 Beach, Voile Rouge Beach, L'Escalet Beach. People wore expensive tans and not much else. One beach was full of nudists except for one lady who wore a neck brace and a French loaf under each arm. Most were beautiful but some had the loose leathery skin of elephants. They just let it all hang out.

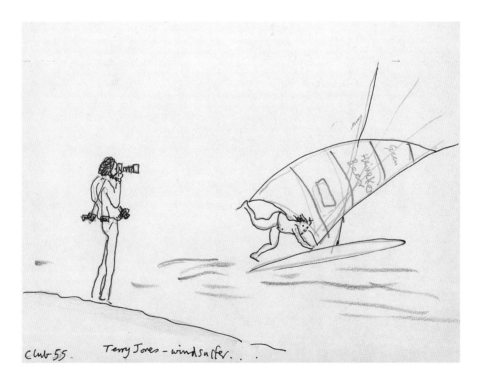

Terry was in his element. Any mystique a writer might have disappears on a nudist beach, especially when he is trying to windsurf.

The Circus closed and was packed into a trunk.
In the night a great wind got up and blew the Summer away.

One night we had dinner in the hilltop town of Gassin, with wonderful views in all directions of bays, hills, woods and mountains. We sat on a sunset terrace, sweet smelling of pine and olives. A mosquito landed on my wrist. 'Kill it,' says Terry, 'or it will go off and bite someone else.' 'Yes, but it won't kill someone else,' says I . . . 'Well, bite it!' says Terry.

On our last evening we found a little circus at Croix Valmar. One acrobat, one clown and a performing black goat called 'Marie Claire'. When the show ended everything was packed into the circus transport – a 2CV with a cut-out shooting star on the roof proclaiming 'CIRQUE'. Memories of this little circus resurfaced when illustrating 'The Chicken Circus' in Terry's *Animal Tales* and 'The Star of the Farmyard' in *Fantastic Stories*.

TOP LEFT: *The hilltop town of Gassin.*
ABOVE: *Little circus at Croix Valmar.*

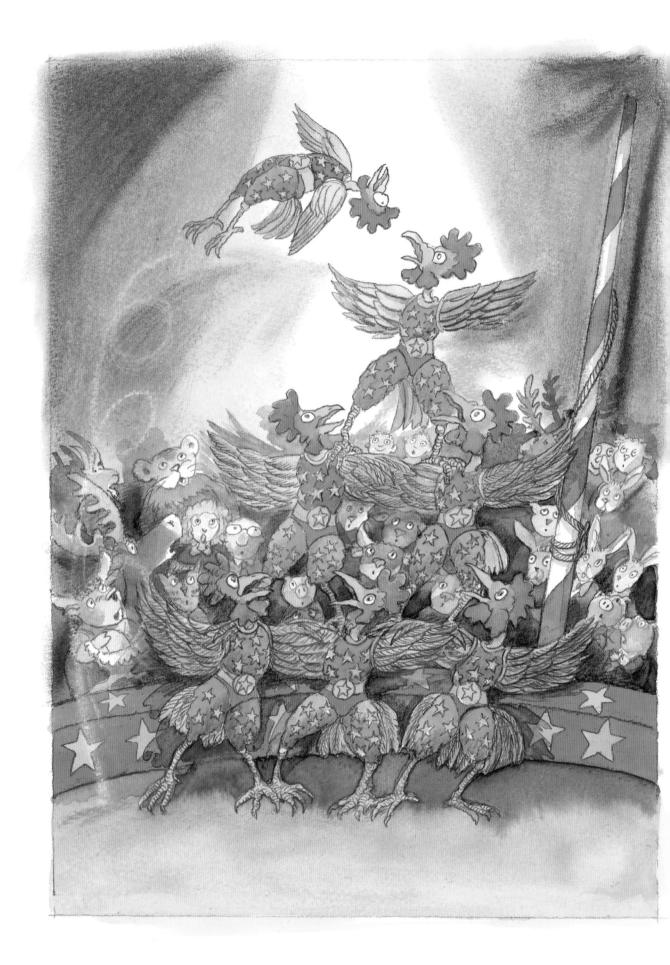

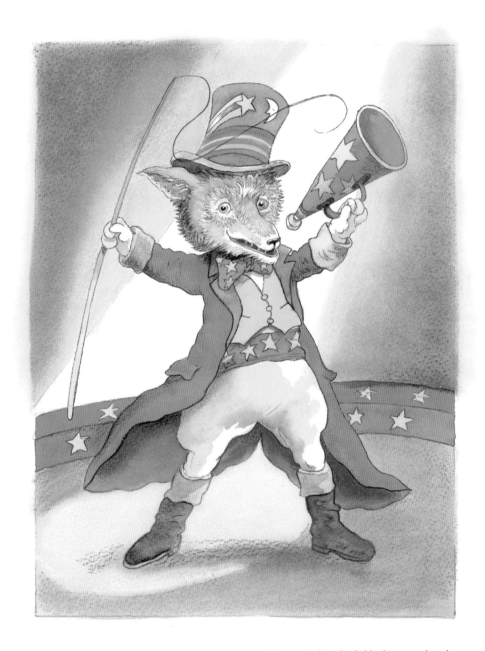

The Circus came to our village once a year. It would be pitched in the field where we played football and we loved hauling on the ropes to hoist the Big Top. Clowns and other circus folk joined in our games and we would watch them feed the roaring lions and scrub the elephant. I never wanted to run away with the Circus, but I did want to be the young guy who collected the money on the 'dodgems' at the travelling Fun Fair. Leaping like a super hero from bumper to bumper, chatting up the girls.

From 'Chicken Circus' in Terry Jones's Animal Tales.

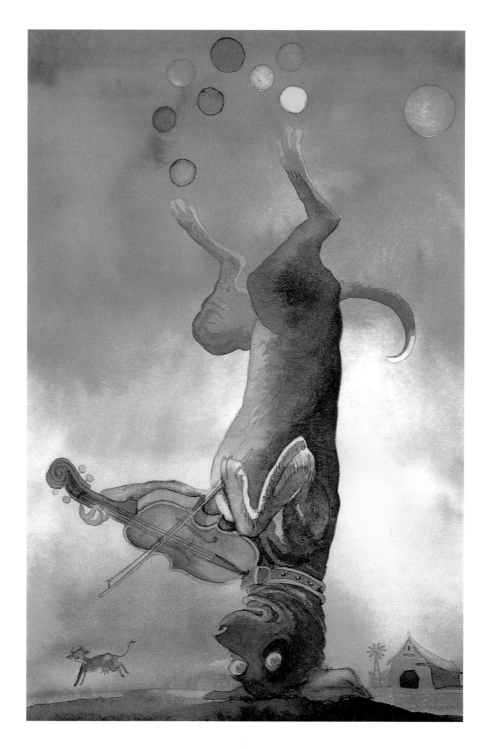

'There was once a dog who could perform the most amazing tricks. It could stand on its head and bark the Dog's Chorus whilst juggling eight balls on its hind paws and playing the violin with its front paws. That was just one of its tricks.'

From 'The Star of the Farmyard' in Terry Jones's Fantastic Stories — *even more amazing than the performing goat in the South of France.*

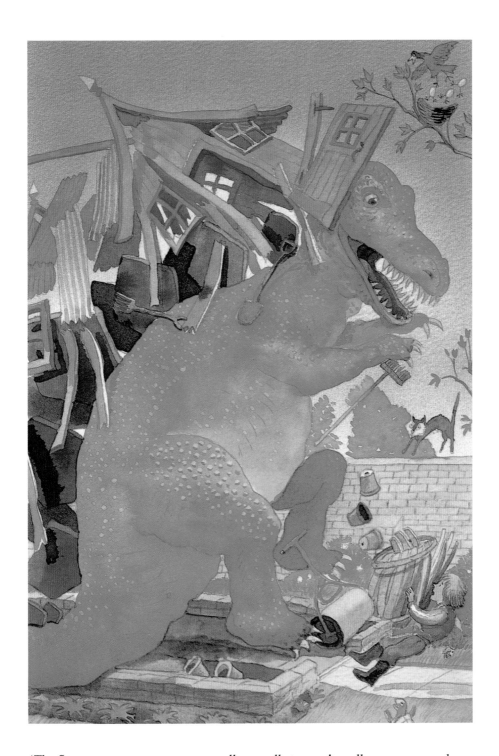

'The Stegasaurus gave a roar . . . well, actually it wasn't really a roar so much as an extremely loud bleat: 'Baaa — Baaa — Baaa!' it roared, and fell back on all fours. Tom only just managed to jump out of the way in time, as the woodshed came crashing down and splintered into pieces.'

From 'Tom and the Dinosaur' in Terry Jones's Fantastic Stories.

Imagine waking up every morning and sitting in front of a sheet of beautiful white paper. By the end of the day it will be covered in colours and marks and lines. A little world which didn't exist before. It might be good, it might be a disaster. However, there's always another piece of paper – and, hopefully, another day. I remember working on a picture for Terry Jones's *Fairy Tales*. It was a picture of an ogre in a dark cave. It was almost finished when I knocked over my cup of Nescafé. The coffee swirled across the top of the picture. I frantically tried to mop it up, but it only made it worse.

Then, as it began to dry, interesting shapes began to form in the darkness of the Ogre's cave. While the paper was still damp, I sprinkled some more grains of instant coffee here and there, adding to the dark, gritty texture. I've tried it several times since. It doesn't always work. It is unpredictable, uncontrollable – but that's what I like about it. Watercolour. It has a mind of its own . . . Go with the flow.

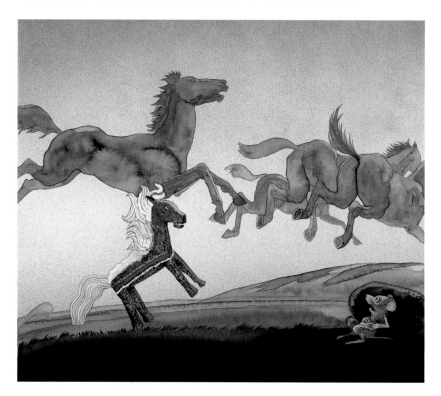

ABOVE: *From 'The Wonderful Cake-Horse' in Terry Jones's* Fairy Tales.

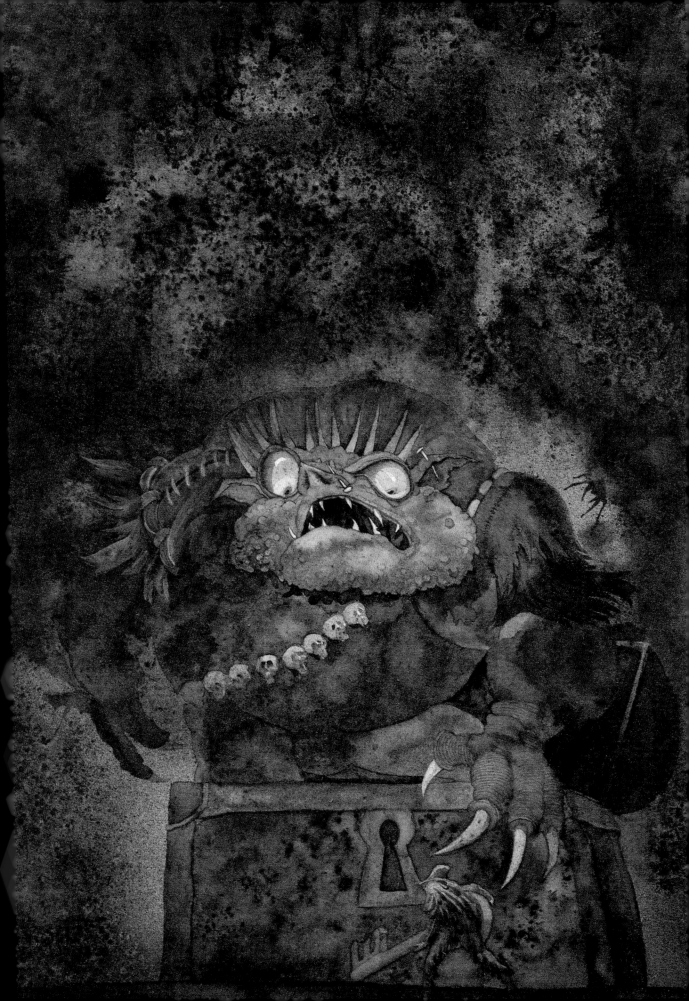

ERIK THE VIKING

When I was asked to illustrate Terry Jones's *Erik the Viking* I went to
Scandinavia for inspiration. I was urged not to put horns on the
helmets because they were historically inaccurate, but I thought
I'd have to because otherwise they wouldn't look like Vikings.
No horned helmets had ever been found. Terry's reaction was
that they just hadn't found any yet, and should keep looking.
So, despite my usual adherence to reality, I applied my 'Artistic
Licence' and Terry ignored his training as an historian. I put
horns on some of the helmets . . .

THIS PAGE AND OVERLEAF: *While drawing North Sea oil rigs I had the
opportunity to sketch the rugged coast of Norway from the sea . . . Very useful
when illustrating the sagas of Erik.*

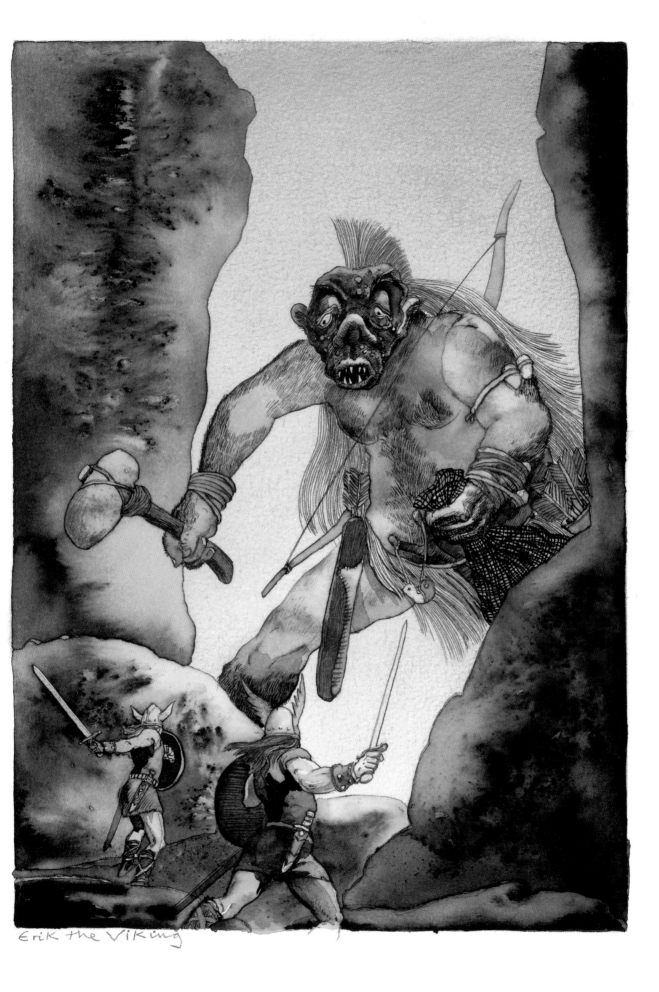

Erik the Viking

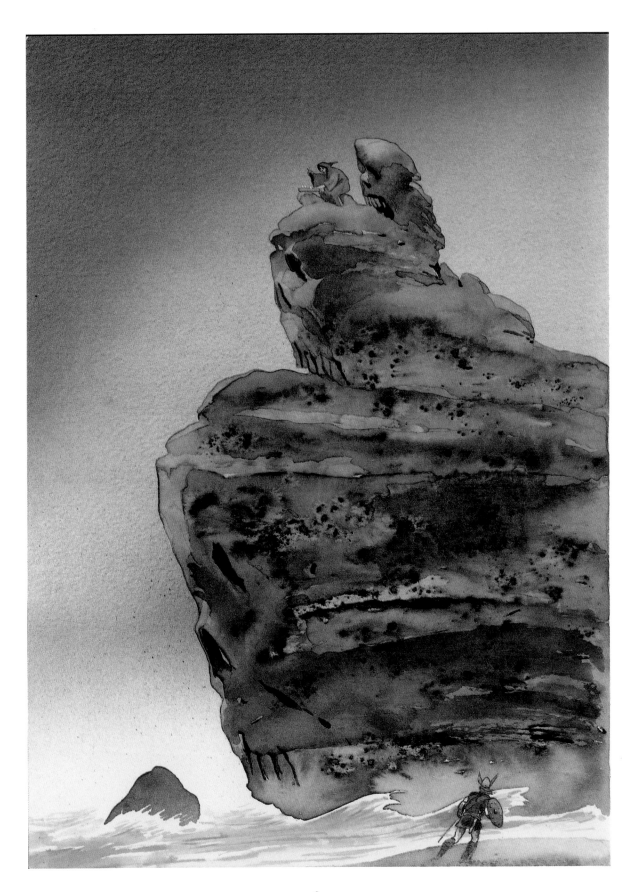

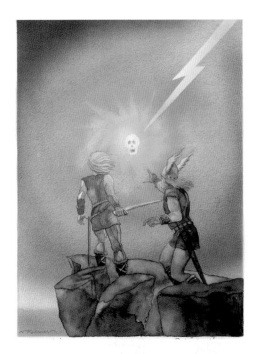

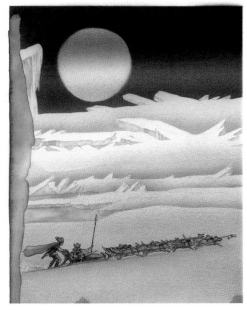

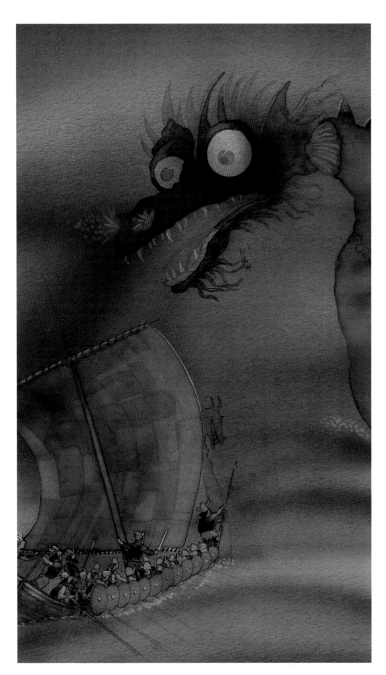

'We have faced the Dragon of the North Sea, we have three times tricked the Old Man of the Sea, we have been turned to stone, we have fought the Dogfighters, we have travelled across bitters snows, we have crossed Wolf Mountain, we have faced spirits and trolls . . . and we have been to the edge of the world and over it . . .'

LEFT: 'Death is waiting for his game of chess'. To add the drama I made each crag a skull upon skull upon skull . . .

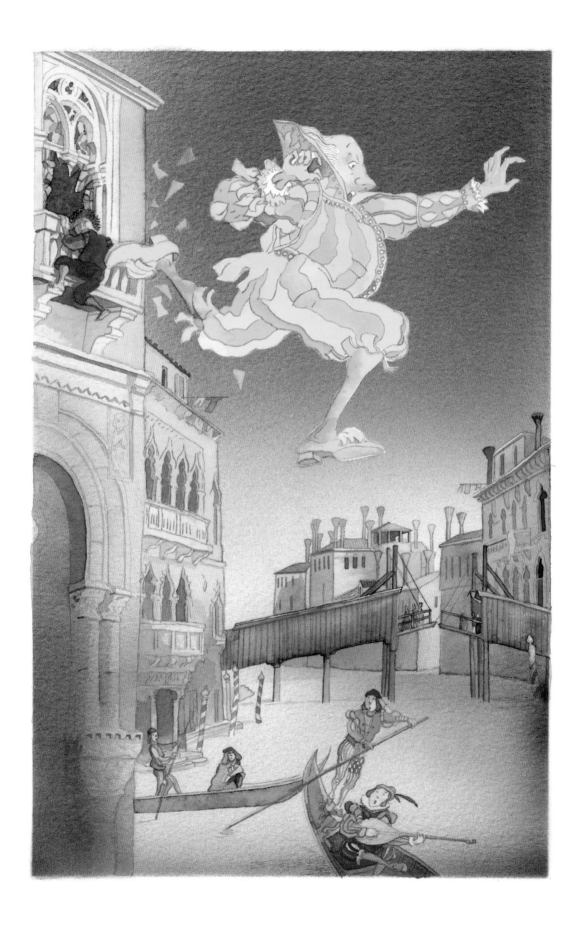

I grab any opportunity to go to Venice and when Terry (over another lunch) mentioned that his next character, Nicobobinus, might live in Venice, I ordered another bottle of wine. When I visited Venice in 1960 it was the first really foreign place I saw. I had been to Amsterdam and Paris, but they shared the same Northern light of my childhood. I saw in Venice another light. The golden Basilica of San Marco seemed from a fairy tale, and the spirit of Marco Polo glinted in the Lagoon.

Venice is so unlike anywhere else, and so compact and rich in its treasures, that it is the perfect place for an instant experience. Strangely, my other favourite short stopover is Venice Beach, California. Visually so different but also intense and colourful – perfect for people watching.

Venice is a great place for walking, particularly in the mists of winter, and a wonderful place for just sitting – a fantastic living stage set with continual entrances stage left and right. To leave a place by boat is best because it is lingering, you leave looking backwards. It is so much better than the endless suburbs and industrial estates encountered on the way to most airports. To leave by boat from the Grand Canal is enough to make you want to leave twice.

Farewell to a love.

'The Grand Canal is a fine sight, but Nicobobinus didn't really appreciate the splendid view he had of it, as he hurtled after the Golden Man — even though he could see right down as far as the Rialto Bridge.'

The Two Michaels

When the postman brings me a brand new story from Michael Morpurgo I feel lucky. Michael Morpurgo not only writes good stories, he writes good pictures. His stories are full of them. Scenes I want to draw. But he is more than a writer – he is a storyteller. Not just words on a page, but words from the heart. From him to you. I can hear his voice in each unique line.

We are often referred to as 'The Two Michaels'. When we phone each other we say 'Hello. It's the other one.'

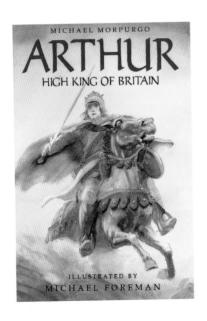
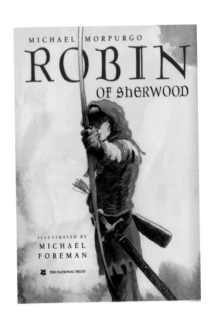

The first book we did together was *Arthur, High King of Britain*. This was followed by *Robin of Sherwood* and later by *Farm Boy*. I try to make my illustrations as true as possible and I like to set the action in the actual landscapes where the story is set. So for *Arthur* the other Michael and I travelled to the beautiful Isles of Scilly where there is an uninhabited island called Arthur's Island. Here, Michael is convinced, King Arthur is buried and waits to return. For *Robin Hood* we went, of course, to Sherwood Forest, and for *Farm Boy* we needed to go no further than Michael's home village in Devon.

These little journeys into the landscapes of our subjects are invaluable in many ways. Perhaps the most important is that, when we are there, we are totally 'in the book', tuned into the atmosphere. By sharing the experience, bouncing ideas off each other, it seems to be all the more powerful. I don't know where Michael will set his next story but hopefully it will be somewhere with sunshine, good food and wine . . . Oh, no, it isn't. The new manuscript has just arrived and it is back to the harrowing reality of the First and Second World Wars. Well – we'll have a pizza together anyway.

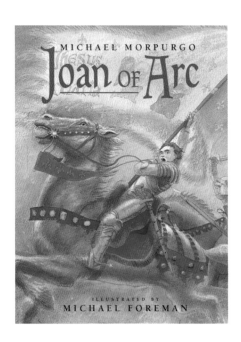

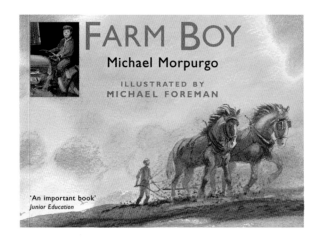

Covers to Arthur, Robin Hood, Joan of Arc *and* Farm Boy – *the sequel to* War Horse.

ARTHUR, HIGH KING OF BRITAIN

I first met Michael Morpurgo as we passed in a corridor at a school in St Ives.
I was leaving, he was arriving. We shook hands without coming to a stop, but
turned around, circling and hand shaking, and spun off on our separate ways.
I called to him to call me when he was next in St Ives. The following summer he
phoned to say he and his family were in Penzance for one night and invited me
and my wife, Louise, to dinner. He popped the champagne as we arrived, the food
was delicious. We loved Clare. An auspicious start. I knew I would like to work
with him.

I thought he would write a great 'King Arthur'. He lived in the West Country,
told wonderful evocative tales, and I could visualize him wielding a broadsword.
When I suggested it, he jumped at the idea. He had been thinking about Arthur
for years. He spent part of every summer in the Scilly Isles and among the
many smaller islands is one called 'Arthur's Island'. A large rocky promontory
forms the unmistakable silhouette of a bearded face. Arthur's face. So here
Michael set his story.

At certain times of the year the high and low tide is so extreme that it is just
possible to walk across the sand bank from one island to another. Michael thought
that a fit, quick boy could get from Bryher to the Western Isles and back before high
tide. Here the story starts – a modern boy who, lost in sudden fog, finds or rather is
found by Arthur.

Michael Morpurgo plots the story . . .

The boy plans his route . . .

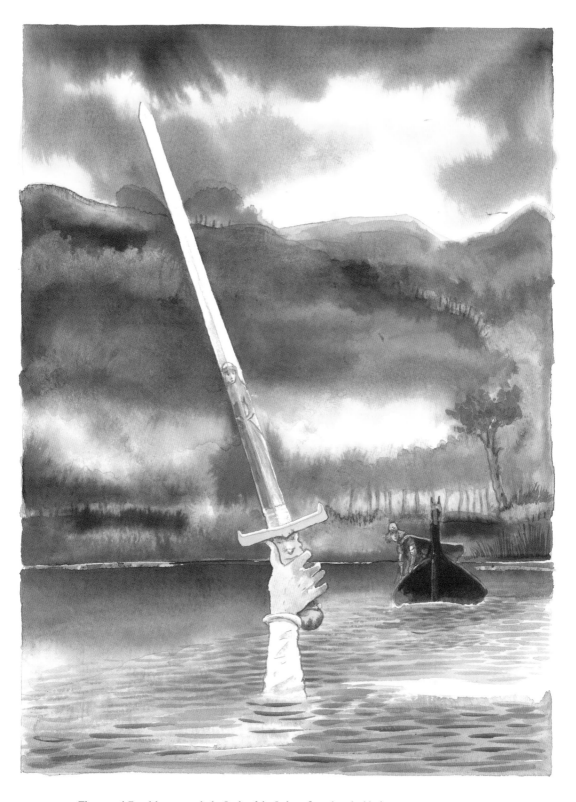

The sword Excalibur — with the Lady of the Lake reflected in the blade.
Illustrations (these pages and overleaf) from Arthur, High King of Britain.

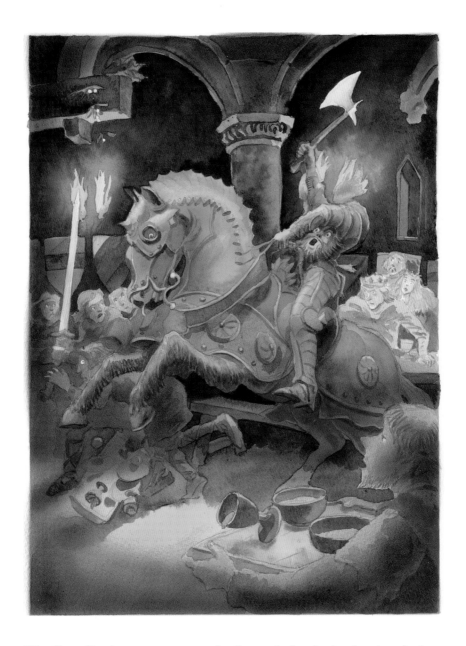

'The Green Knight sprang at once to his feet, picked up his head and vaulted headless onto his horse. It was the severed head under his arm that spoke.'

OPPOSITE: *In one of the crowded battle scenes, there is a face looking straight out at the viewer — the 'ordinary Joe' caught up in the action. That's partly because I know that I'd more likely be the poor foot soldier getting whacked on the head, not a knight on a big horse, and I would like the reader to connect with that person.*

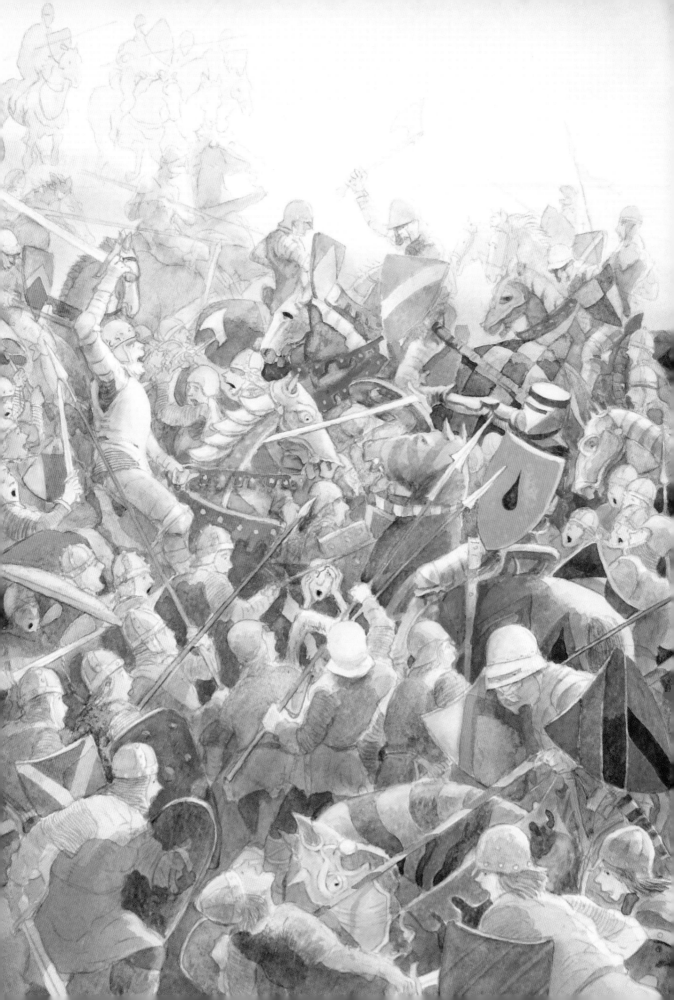

I first showed Michael Morpurgo the pictures for *Robin of Sherwood* at his home in Devon. The poet, Ted Hughes, was there, sitting by the fire. Looking at the pictures, he said, 'real worlds, real woods'. The days in Sherwood Forest had been worth it. I drew the kind of trees we would love to climb as boys. The kind I could imagine Robin and his men hiding in, ready to pounce.

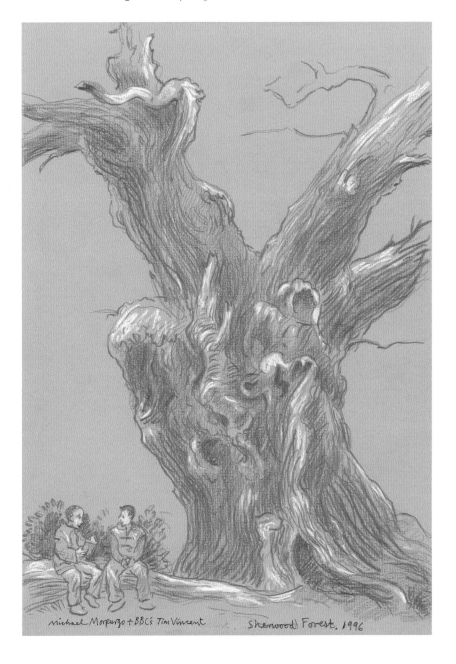

When Michael and I were working on the book, the BBC Blue Peter programme came to film us in Sherwood Forest. They had previously filmed us at work on Arthur, High King of Britain *in the Isles of Scilly.*

I imagined us boys with the outlaws waiting to ambush the little old ladies of Pakefield coming through the woods with their shopping. The bumpy lane on the edge of the village green was the perfect place for outlaws, highwaymen and naughty boys.

7th Sept.

Courson. The Bar.
Little fair in the square. Café arbait in the
sun. Past chateaus and white cows,
vines, bought case of wine from vineyard
and a detour to Crest. Narrow streets
and alleys piled up to the old walls of
the Castle. Huge castle 'like a
gas cooker' with a tin Tricolor on top.
Endless meal — + wine ..

Valley of the Rhone – breakfast
of fallen apples

JOAN OF ARC

After *Arthur High King of Britain* and *Robin of Sherwood* we thought of various other likely heroes – but why not a heroine? As soon as 'Joan of Arc' was mentioned we knew it was inevitable. Eventually Michael sent me the first chapter through the mail. Handwritten in spidery writing on thin faded paper. He likes to write sitting up on his bed like Robert Louis Stevenson.

Then we went on a little trip – Michael and his wife Clare and I – to Orléans in France, the scene of one of Joan's great victories and where there is the Joan of Arc Archive and Museum. The museum, in addition to armour, artefacts, banners and weapons, had detailed panoramic models of the great battles – the Siege of Paris and the Battle of Orléans – and contained copies of every book published about Joan, every image of her, including all the movies, and thousands of engravings of the places and events of her short life.

TOP: *I made a sketch of this orchard in the Rhône Valley while travelling in France with Terry Jones in 1982. It seemed the ideal setting for Joan and the image of the Angel.*

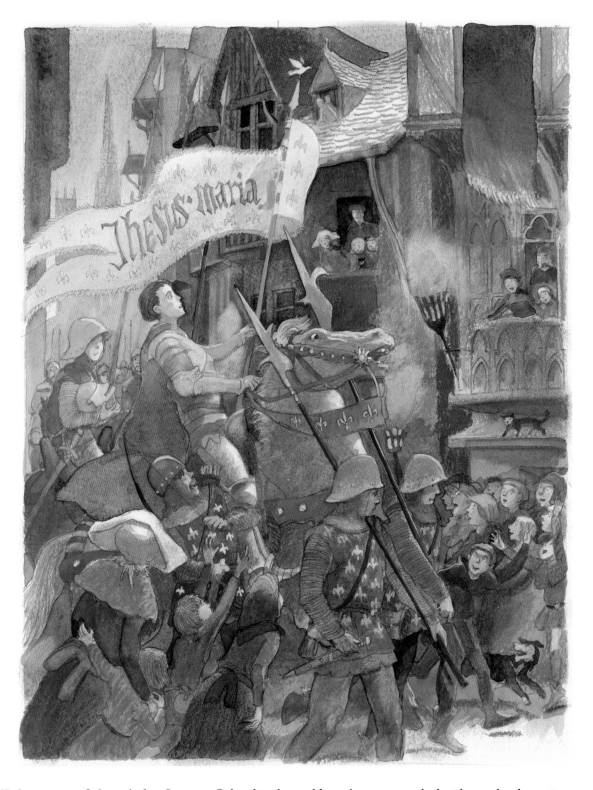

'Belami was in Orléans before Joan . . . Below him he could see the streets packed with people, the entire city lit by their torches . . . she rode in through the city gates and was at once enveloped by adoring crowds.'

The details were invaluable to me: the kinds of boats used to carry hundreds of war horses across the wide river; how they transported cannon and cannon balls and scaling ladders; the kind of helmets the opposing armies wore. So many little details which make the big picture. We walked the banks of the Loire, wide and dotted with small islands with scrub which would have provided cover, but also mud flats which would have caused treacherous currents.

One afternoon we were walking along a narrow cobbled street lined with tall medieval houses. Suddenly, a young man with wild eyes came and started jabbering at Michael. I thought, 'Oh no. The local loony or Morpurgo's French fan club.' 'I think he wants us to go round the corner and do something for him,' said Michael. We followed him around the corner and there stood another man. A Big Man, chewing tobacco and carrying a coil of thick rope. I glanced at Clare and was glad she was there to look after us. Behind the Big Man was what looked like the scene of a savage attack. One of those small tinny French vans seemed to have been assaulted by a giant sofa. Maybe it slipped the Big Man's leash and pounced on the van.

The man with the mad eyes jabbered again and pointed at the giant sofa – and then at the tall narrow medieval house on the corner. Then he pointed to an open window on the very top floor. Visions of Laurel and Hardy and the piano flickered through my brain. 'Michael! Your back! You can't possibly,' said Clare. (Michael was suffering from Milk Maid's Back. I knew – I had been carrying his bags all day.)

Michael and I followed the Mad Man up a wooden spiral staircase. Such a beautiful, simple staircase. Creaking as it had for centuries. Michael and the Mad Man stood in the frame of the window and I was behind them as the anchor man on the end of the rope. The room was filled with religious pictures and texts. 'One, two, three, heave!' 'One, two, three, heave!' The Big Man was shouting from below and studying the sofa as it slowly rose from the groaning van. Clare had stopped warning Michael about his back and had collapsed into fits of laughter in the gutter. Eventually, after various snags, the giant sofa elbowed its

way through the window and into the room. The Mad Man sat on it, beaming. We clattered back down the beautiful stairs and into the street. Clare was drying her eyes, and the Big Man was coiling his rope and chewing his tobacco. He nodded his approval. He knew a couple of professionals when he saw them.

Later that evening we were walking back to our hotel after dinner along the same narrow street. We stopped for a nightcap at the Bar Shakesepeare, drinking in the atmosphere. It was dark, with no traffic, just a few late night drinkers and cats slinking around in the shadows. By now we had studied our maps and realised that this was the very street along which Joan had led her victorious army when she entered Orléans.

The window which had framed Michael and the Mad Man would have framed cheering faces, and the winding wooden stairway of the house would have echoed to the clatter of hundreds of excited feet as the population poured out into the street to welcome Joan. The Mad Man would have followed her because he would have believed her 'voices' and the Big Man would have followed her because he was a Frenchman, and would have liked to remove the English.

The story of Joan had suddenly 'come alive' for me. It had become a living story in a living city. It felt like Joan had just passed by at the head of her army. Past these same houses, clattering over these same cobbles, armour glinting in the torch light and cats slinking in the shadows. It was no longer 'long ago and far away'. It felt close, personal and about to be very bloody.

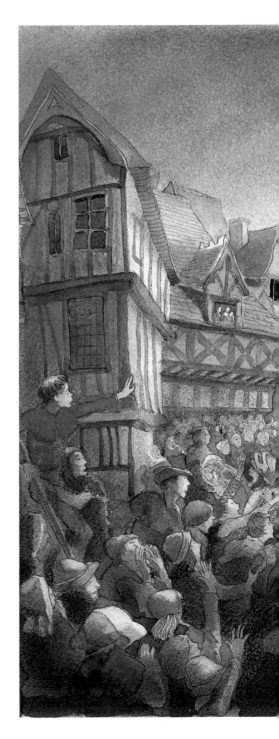

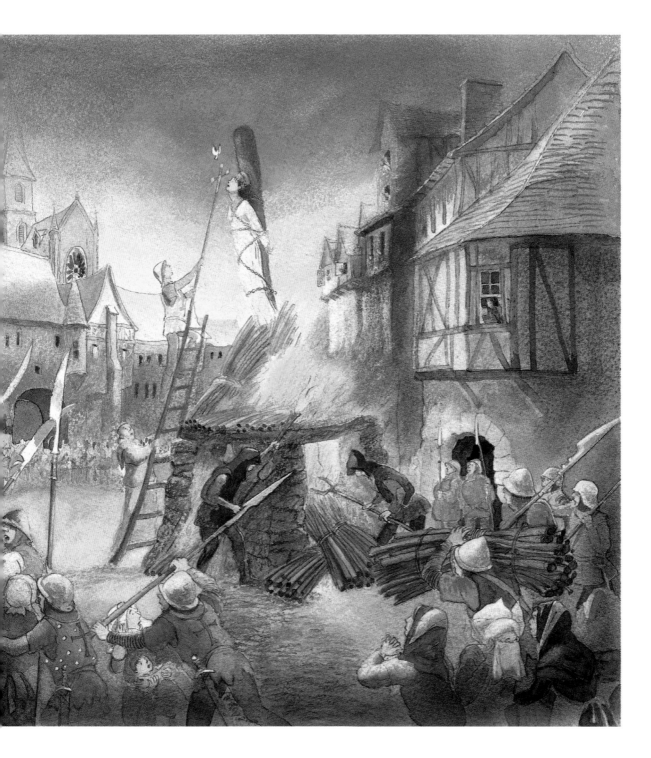

We journeyed on to the other key locations ending eventually at the main square in Rouen,
the site of Joan's burning at the stake. Again, many of the buildings are intact.

FARM BOY

In the Spring of 1996 my family and I broke our journey to
Cornwall and enjoyed Clare and Michael's hospitality on their
Devon farm. While watching kingfishers darting along their
riverbank, I bored them by reminiscing about my childhood visits
to a Suffolk farm during the Second World War, when we boys had
helped with the harvest, chased rabbits and gathered mushrooms.

Farming was changing back then, and although the farmer had recently acquired a tractor, he still used his beloved horses. 'Is there an idea there?' I asked the other Michael. He thought for a while and then said one word: 'Joey.' I jumped at the idea! *Farm Boy*, is about how the returning 'War Horse', Joey, has to adapt to the hard life on the farm and show what a true hero he is. It filled in the period for me between *War Game* and *War Boy*, and was a natural sequel to *War Horse*.

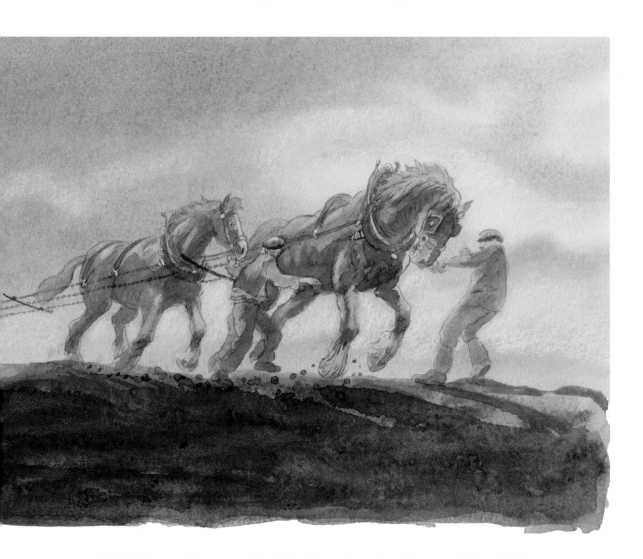

Michael Morpurgo's epic story of Joey, **War Horse***, has achieved fame around the world. In this sequel,* **Farm Boy***, Joey returns to his home village and is set to work on the farm, and is victorious in a different kind of battle.*

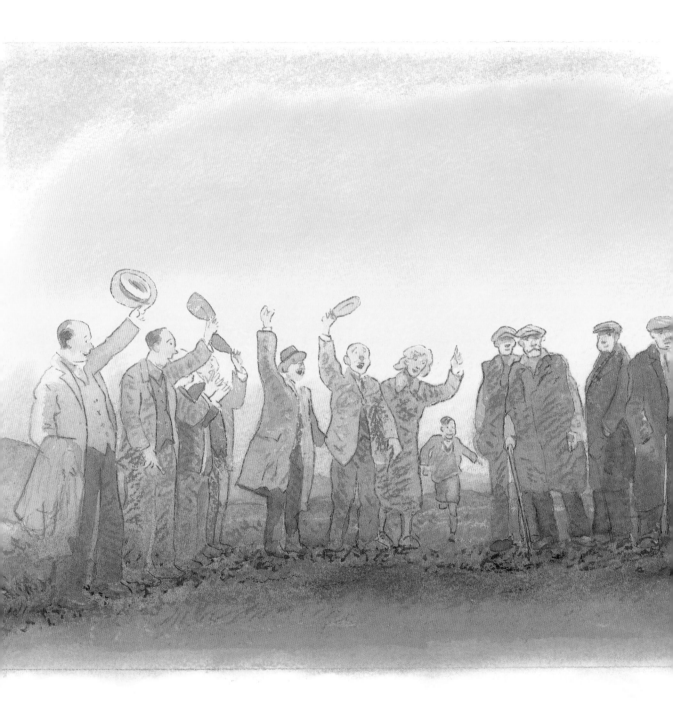

'That evening with the help of a dozen or more men we pulled the Fordson back onto his wheels. We couldn't start him though so we hitched him up to Joey and Zoey and between them they pulled him all the way across Burrow Brimclose and into the barn. They enjoyed that I reckon. So the Fordson was ours forever and Joey and Zoey never had to plough again.'

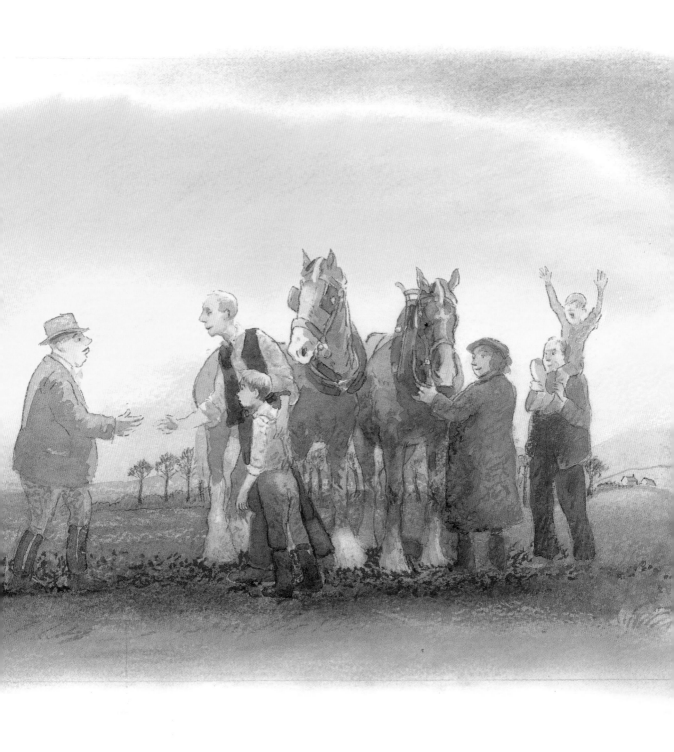

I remember the other Michael sitting on a log in Sherwood Forest, making notes while I drew trees. 'This is fun,' he said. 'What tale should we tell next?' 'Well, I've always wanted to do a book about football,' I said. 'But football the way it used to be. Before footballers became millionaires. Football as it was when I was a boy.' Michael gave me a blank stare, and went back to his note taking.

Then, a few months later I took him to a Chelsea game, a Champions League match. Michael had never been to a big football match before and being swept along in a sea of shouting, singing and the crush to get in was new to him. Then came the sudden spectacle of the brilliant green floodlit pitch, flags and the European anthem. One of those special nights. I pointed to a row of Chelsea Pensioners in their red uniforms high in the East Stand. 'They get free tickets to every game,' I said. Then I pointed to the far end of the ground, behind the goal. There, in the vast, heaving crowd was one Chelsea Pensioner. 'Why is he there?' asked the other Michael. 'Why isn't he in the free seats with his mates?' 'Because he wants to watch the match from the same place where he used to watch when he came as a small boy riding on his dad's shoulders.'

So Michael began to dream. There was a whole lifetime to be lived by that little boy perched on his dad's shoulders before becoming the old soldier in his Chelsea Pensioner red coat down at the Shed End. Michael called the little boy Billy – Billy the Kid. *Billy the Kid* is the story of Billy, a Chelsea pensioner, who is looking back at a lifetime of memories. There were the tough times when his mother had to struggle to keep the family going after his dad died and when he himself was a prisoner of war on the run. But most of all he remembers 1939, the year his dream came true and he was picked to play football for Chelsea. But it is 1939 – and his dream is shortlived.

Illustrations from Billy the Kid.

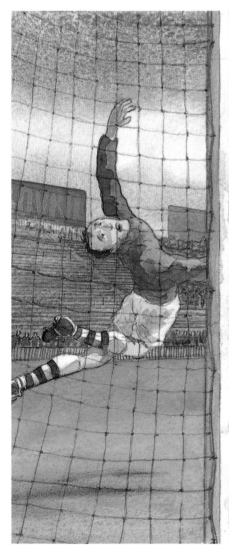
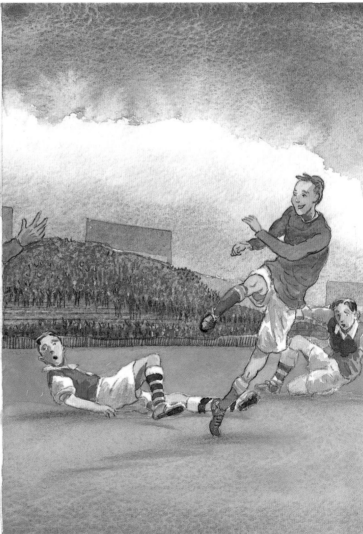

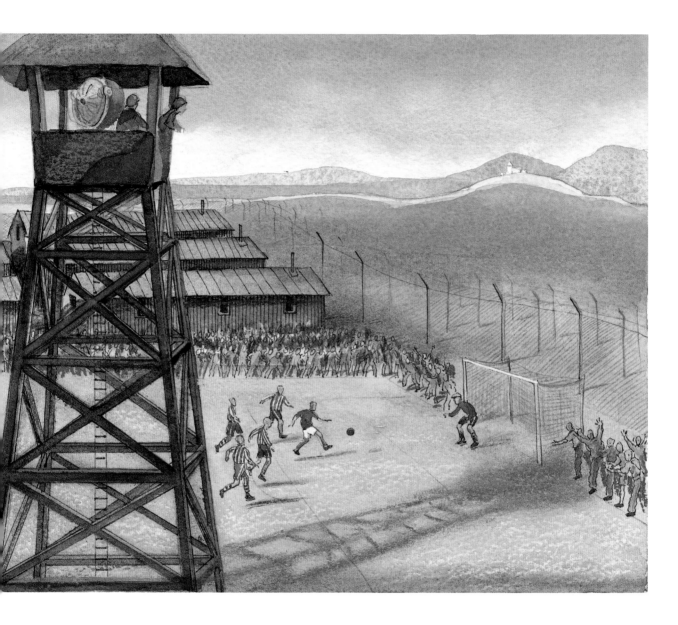

The next game he was to play was in a PoW camp.

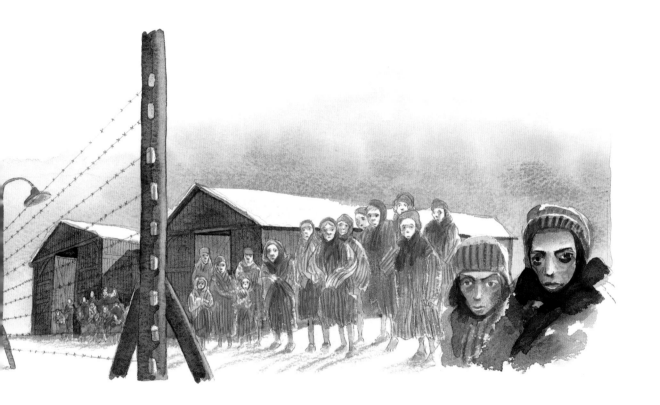

After his escape, a worse camp was to follow. Billy, as an ambulance driver, was to be witness to the horrors of the Holocaust. The visual research for this part of the story was horrendous. Photographs of families arriving at the death camps – and the children always staring at the camera. They look at *you*. They don't know what is going to happen to them – but *you* do.

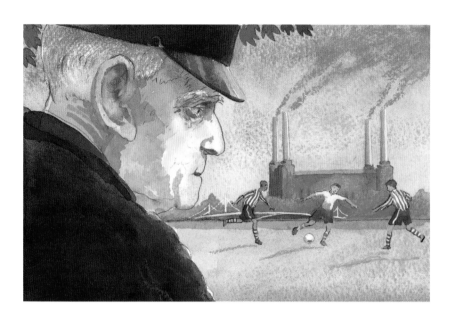

OLD BILLY

The drawing of old Billy is based on my old friend George Goddard, a Fulham gardener. He worked in our garden every Monday morning. As I drew his portrait I told him the story of 'Billy the Kid'. George then told me his story. At the start of the War he joined the Ambulance Corp (like Billy). He was sent to the North African desert (like Billy), captured and imprisoned by the Italians (like Billy). But, when given the opportunity to escape (like Billy), George stayed in the prison camp. He wouldn't desert those prisoners too badly wounded to escape. He stayed with the wounded and was a prisoner of war for the rest of the War. A real hero and a lovely, gentle man.

'I was made an honorary member and given my seat at the Shed End for free for the rest of my life. It was in all the newspapers. So down at Chelsea they all know who I am now. I'm quite famous in a sort of a way, and I like that. In fact, I like that a lot.'

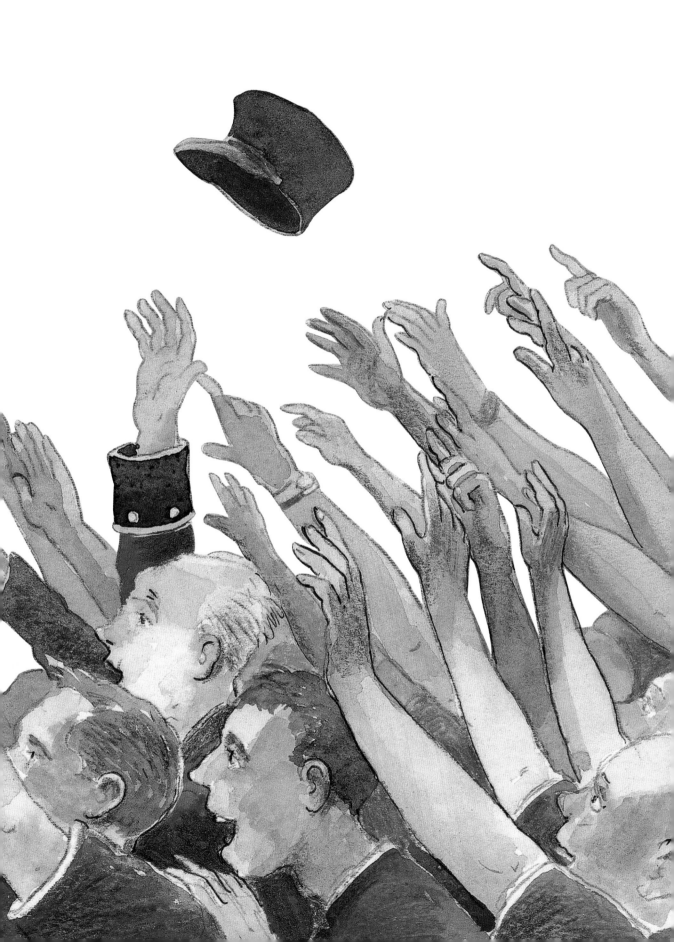

New Beginnings

When writing *War Boy* I, naturally, compared my memories with those of my family. Family has continued to be a rich source of stories. What our young boys did and said and imagined as they experienced the world, gave us endless pleasure and gave me so many ideas for books.

Ted Hughes once told me that when his children were young, ideas for children's poems and stories 'welled up like mother's milk, and when the children had grown, that particular inspiration dried up'. I was to reflect on this later when our own little grandchildren provided another burst of wonder.

Thumbelina, from Classic Fairy Tales.

Ben in our old London home. From A Christmas Treasury.

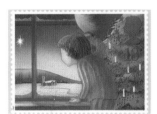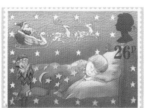

*When I was asked to design a set of Christmas stamps for the Post Office in 1987,
I remembered the Christmas Eves of my childhood. Laying awake, listening for sleigh
bells. Waking very early and fumbling for presents in the dark. Our son Ben was just
the right age and features on the stamps.*

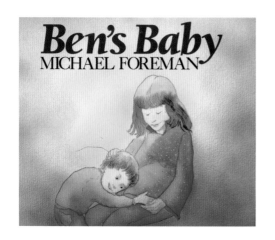

On Ben's third birthday, we asked him what he would like for his next birthday. He said, 'A baby'. We did our best and, twelve months and one day later, his brother Jack was born. As the boys grew, their ideas grew. Ben went from wanting a baby brother to imagining a magic box to transport him from our kitchen into Outer Space (*Ben's Box*). Jack went from an imaginary voyage (*Jack's Fantastic Voyage*) to building his own raft to make a dream a reality (*Jack's Big Race*). Even our beloved cat and my mother-in-law's goldfish prompted stories (*Friends*). Ideas are everywhere.

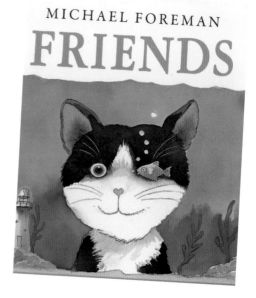

Now, with young granddaughters, there is a renewed fount of innocent inspiration. Last week, on turning four, little Scout was told that we would need to start thinking about a new school uniform for her. Her eyes grew wide and she exclaimed 'A SCHOOL UNICORN! WOW! How do we get one of those!' Now, there's an idea . . .

When I lay on the floor, as a boy, drawing on paper from a biscuit tin, I had no idea where it might lead. I didn't know that this was to be my magic carpet. That dreaming dreams would show me the world. That drawing the world would fulfill my dreams. The books are my footprints – steps along a journey blessed by good fortune. The fire bomb in the fireplace. Growing up in a sweet shop. Seeing the sun set in a Cornish sea, day after golden day . . . Lucky, lucky boy . . .

Lucky, lucky boy.